INSPIRED!

TRUE STORIES BEHIND FAMOUS ART, LITERATURE, MUSIC AND FILM

D1055727

MARIA BUKHONINA

MUSEYON, NEW YORK

Library of Congress Cataloging-in-Publication Data
Names: Bukhonina, Maria, author.
Title: Inspired! : true stories behind famous art, literature, music, and film / Maria Bukhonina.
Description: New York : Museyon, [2016]
Identifiers: LCCN 2016036933 (print) | LCCN 2016044804 (ebook) | ISBN 9781940842073 (paperback) | ISBN 9781938450822 (e-Pub) | ISBN 9781938450839 (e-PDF) | ISBN 9781938450846 (Mobi)
Subjects: LCSH: Biography. | BISAC: BIOGRAPHY & AUTOBIOGRAPHY / Artists,Architects, Photographers. | ART / History / General.
Classification: LCC CT104 .B85 2016 (print) | LCC CT104 (ebook) | DDC 920.02--dc23
LC record available at https://lccn.loc.gov/2016036933

Published in the United States by:
Museyon Inc.
1177 Avenue of the Americas, 5th Floor
New York, NY 10036

Museyon is a registered trademark.
Visit us online at www.museyon.com

ISBN 978-1-940842-07-3

0615280
Printed in USA

INSPIRED!

To my family, my inspiration for everything

What drives creativity? Where does inspiration come from? Does an artist need to be in love, suffering or borderline insane to create memorable work?

As I found out, there are many answers.

I was inspired to explore the mysterious nature of creativity after encountering the biography of author Patricia Highsmith. Her work showed a deep loathing of humanity, resulting in unforgettable literary characters, from psychotic Mr. Ripley to murderous snails. It made me wonder what real-life events inspired other creators of the world's most memorable art, literature, music and film. What I discovered was fascinating.

For some, like French artist Toulouse-Lautrec and Italian painter Modigliani, it was their health problems that drove them to create art with abandon. Others were inspired by their family history, like *Three Musketeers* creator Alexander Dumas, who was a grandson of a Haitian slave, and Andy Warhol, whose immigrant Slovakian heritage provided the foundation for his artistic expres-

sion. Many were inspired by love—from Salvador and Gala Dalí to Lucille Ball and Desi Arnaz—but even these stories are not without their own twists and turns.

This book also traces the unexpected ways inspiration flows between creators, their work and their audience. Such is the story of Sir Arthur Conan Doyle, who couldn't wait to murder his creation, detective Sherlock Holmes, so he could focus on "more serious" work; or the complex relationship between George Lucas and *Star Wars* fans who both worship Lucas for creating the *Star Wars* universe and detest his every attempt at updating it.

The stories in this book span centuries and continents, from Napoleon's France to modern-day Hollywood, and star everyone from a general to gangsters and even a dog that inspired a whole country.

I hope the stories in this book will inspire you, as they did me, to never stop creating your own destiny.

—Maria

CONTENTS

CONTENTS

1

"There are two ways of seeing: with the body and with the soul. The body's sight can sometimes forget, but the soul remembers forever."

—Alexandre Dumas,
The Count of Monte Cristo

ALEXANDRE DUMAS

The Black Musketeer

Inspired by the achievements and the struggles of his mixed-race father, the author of The Three Musketeers created heroic fictional characters that made him the best-selling author in the world.

There is hardly anyone who hasn't read or heard about *The Three Musketeers* and *The Count of Monte Cristo*. But not many people know that these immortal characters were created by a grandson of a slave who had to teach himself to read and write.

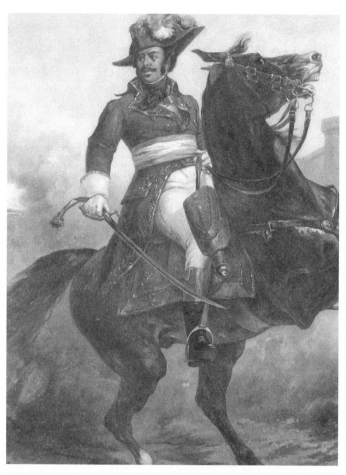

Portrait of General Dumas by Olivier Pichat, after 1883, Musée Alexandre Dumas

Alexandre Dumas remains one of the world's most well-known authors, almost 150 years after his death. *The Three Musketeers* and *The Count of Monte Cristo* have inspired generations of readers and prompted hundreds of film adaptations, plays and even video games. What inspired Dumas himself was a long family history of injustice and prejudice—and the life of his father, a real hero.

The writer's father, Thomas-Alexandre Dumas, was born in 1762 on a plantation on Saint-Domingue (now Haiti), among French nobility and African slave labor. Thomas-Alexandre's fate was twisted from the very start: His father, French diplomat Marquis Antoine Davy de la Pailleterie, purchased his mother, Marie-Cesette Dumas, to be his slave—and concubine. She bore him a son and three daughters. When young Thomas-Alexandre turned 13, his father returned to France. He took Thomas with him, but left behind the boy's mother and siblings— whom he sold to the plantation's next owner.

Although the marquis gave his son the education appropriate for a noble youth in France at the time, including horseback riding and fencing, Thomas-Alexandre could not hide his mixed bloodline. He grew up tall, strong, educated—and black.

France might have been very liberal then, but Thomas-Alexandre would always be reminded that he

was not like other noble sons in Paris. One night, Thomas-Alexandre took a beautiful white Creole woman to see a play at Nicolet's Theater. When three officers from an elite naval unit approached their box, he knew they were looking for trouble. One of the men, Officer Titon, complimented the lady's breasts and offered to show her around Paris, as if Thomas-Alexandre wasn't there. When Dumas responded to the insult, the officers called him a mulatto and tried to force him to kneel and beg for their permission to be excused. The woman fled the ugly scene, while the men were taken outside by a theater guard. The incident ended when Titon decided not to press charges. Thomas-Alexandre had to swallow his pride.

With four generations of nobility on his father's side, Thomas-Alexandre expected an officer's position when he decided to fulfill his duty to France by enlisting in the army. French race laws canceled out his right to the position, however. Undeterred, Thomas-Alexandre enlisted as a private. The outraged marquis prohibited his son to use the noble family name with a low rank. That was the pivotal moment when Thomas-Alexandre took his destiny into his own hands: He signed the enlistment order with his slave mother's last name—Alexandre Dumas, "son of Antoine and Cesette Dumas"—completely erasing his father's noble pedigree and precious family name from his story. Just two weeks later, the marquis

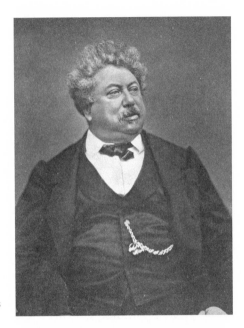

Alexandre Dumas

passed away unexpectedly. Thomas-Alexandre did not attend his funeral.

What followed is one of the most remarkable military careers in French history: Thomas-Alexandre worked his way from a quiet post in a province to a commanding position in the "Black Legion" to brigadier general in the regular French army. Within a year, he was promoted to commander in chief of the French Army of the Western Pyrenees. Despite his mixed race, General Dumas soared

from the lowest military rank to leading an army in just seven years.

When General Dumas came to serve under Napoleon's command, tension flared between the two immediately. Dumas disapproved of Napoleon's ruthlessness and the way French troops abused the locals. Napoleon demoted him whenever he could, yet couldn't help but admire his bravery and strategic skills. The enemy, the Austrian army—both in awe and fear of him—nicknamed General Dumas "The Black Devil."

General Dumas was faithfully by Napoleon's side when the French armada invaded Egypt in 1798. Sent on the most impossible missions, General Dumas never backed down, from storming the city walls of ancient Alexandria to delivering ransom to the desert Bedouins for the captured French soldiers. The fearless black general looked so large and dominating next to the short-statured Napoleon, some Egyptians mistook him for the commander in chief. That didn't help his popularity with Napoleon.

The increasingly paranoid Napoleon didn't wait long to get rid of the inconvenient hero. Shortly after General Dumas boarded a ship to return home, it made a stop in Taranto, Italy. Dumas and his companions were captured as prisoners of war and locked up in a dungeon. Napoleon did nothing to free his loyal compatriot. Dumas

stayed underground for two years until one of his fellow generals finally came to rescue him. Dumas emerged partially paralyzed, blind in one eye and deaf in one ear. He returned home to his wife and children, but never recovered, dying a painful death five years later from stomach cancer and in dire poverty. The family was denied a general's military pension by the spiteful Napoleon.

When the general died, Alexandre Dumas the future writer was just a toddler. His time with his heroic father was short, but filled with stories of epic adventures. The family could not afford to educate him, but Alexandre had fire in his veins: He taught himself to read and write. Inspired by the stories of his father's incredible life, Alexandre resolved not to let any circumstances defeat him. When he was 20 years old, Alexandre Dumas moved to Paris to start a new life with nothing but loose change in his pocket.

In spite of his limited education, Alexandre Dumas showed immense literary talent, and much like his father, quickly rose through the ranks of Parisian society. But when he became a literary sensation and rich, critics went after him. They said a mixed-race man with no formal education couldn't possibly have written all those novels. It got worse. At one of the lavish dinner parties regularly thrown by Dumas in his mansion, a guest at the table compared General Dumas to a monkey. Always in

good spirits, Alexandre Dumas retorted with ease: "My father was a mulatto, my grandfather was a Negro and my great-grandfather a monkey. You see, sir, my family starts where yours ends."

For years, Dumas stoically absorbed every racial insult thrown at him. His revenge was the immense popularity of his works. He put something of the brave general into all of his main characters. His father's memories of the incident at the theater served as inspiration for D'Artagnan's many troubles in Paris as a provincial outsider. The general's war stories gave rise to the four musketeers, who got in trouble with government figures, but never lost their sense of honor. His father's capture and time in the Italian prison became the main plot device in *The Count of Monte Cristo.* Clearly, Dumas was not letting any family history go to waste—it all fueled his imagination.

Alexandre Dumas was prolific and successful in every genre, publishing more than 100,000 pages in his lifetime, including plays, historic novels, travel memoirs of Russia and a culinary encyclopedia. He lived life to the fullest, earning fortunes from his writing and spending them all on parties and romantic affairs. A contemporary described him as "one of the most generous, large-hearted people in the world." He was rumored to have had close to 40 lovers and to have fathered several children,

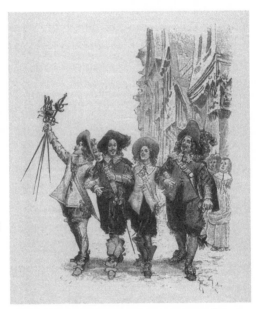

D'Artagnan, Athos, Aramis and Porthos from *The Three Musketeers*. Illustrations by Maurice Leloir, 1894

one of whom, known as Alexandre Dumas the son, became a successful writer in his own right.

Alexandre Dumas died in 1870. In 2002, French President Jacques Chirac hosted a momentous event: The ashes of Alexandre Dumas, a grandson of a slave, were transferred to a mausoleum in the Panthéon of Paris, next to Jean-Jacques Rousseau, Victor Hugo and René Descartes. On the day of the ceremony, all of Paris was

outside while people in the rest of the country were glued to their TV sets to watch a once-in-a-lifetime scene: a coffin draped in blue velvet and escorted by four guards on horseback, dressed as four musketeers.

To this day, General Thomas-Alexandre Dumas is one of the most decorated military officers of color. *The Three Musketeers,* its sequels and *The Count of Monte Cristo,* all based on his exploits, have been translated into more than 100 languages and continue to be international best-selling novels.

2

"She was the most complete incarnation of womankind that has ever existed."

—Franz Liszt
on Marie Duplessis

MARIE DUPLESSIS

THE ORIGINAL PRETTY WOMAN

French courtesan Marie Duplessis lived a short life, but her tragic story inspired some of the most well-known and beloved works of literature, theater, music and film.

The 1990 Hollywood hit *Pretty Woman*, with Julia Roberts and Richard Gere, is one of the most popular romantic comedies of all time. Combining both the traditional Cinderella tale and a modern cinematic trope of "the hooker with a heart of gold," *Pretty Woman* is a classic film in which love conquers all.

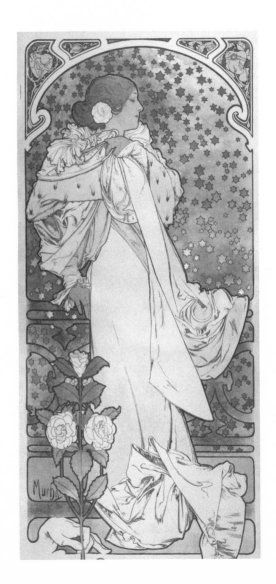

Poster of Sarah
Bernhardt, *La Dame
aux Camélias*, 1896.
Alfons Mucha

What lies beneath is the much darker real-life story of a 17th-century French courtesan, Marie Duplessis, whose life inspired a best-selling novel, a famous play, one of the most popular operas in history and many hit movies, including *Pretty Woman.*

Marie Duplessis was born Alphonsine Rose Plessis into a peasant family in Normandy, France, in 1824. Her father, Marin Plessis, an illegitimate child of a prostitute and a priest, was a raging alcoholic, who beat his wife, Marie, mercilessly, especially for giving him two daughters and no son. Marie escaped the abusive marriage by finding a job as a maid in a distant city, hoping to make enough money to save her two children, but she died when Alphonsine was only 6 years old.

Marin promptly abandoned his daughters, and Alphonsine spent several years on her own, surviving by begging for food and shelter from relatives and local farmers. As she grew older, Alphonsine found work as a laundry girl. It was not until she turned 13 and her beauty started to blossom that Marin returned—and promptly found a way to make money off his daughter by setting her up with a local septuagenarian bachelor with a bad reputation. Alphonsine spent every weekend at the house of the old man, who paid her several times her laundress wage. From then on, Alphonsine's father passed her from one pair of hands to another, until she ended up on the

streets of Paris at 15, alone and often hungry for days.

Eventually, Alphonsine found a job at a dress shop. A quick learner hungry to advance in the new city, she soaked up Parisian culture, the latest fashion and what the lifestyle of the rich was like. Both her taste and her beauty grew more refined every day. Petite, with ivory skin, huge dark eyes and delicate features, Alphonsine attracted the attention of many, until a Parisian widower in his 40s offered her a rented flat and a monthly cash stipend, which greatly exceeded her meager shop wages, in exchange for her affection. Her career as a Parisian courtesan was launched. For her new life, Alphonsine adopted a more noble-sounding name: She added a "du" and became Marie Duplessis. Hoping to erase her dark past as an impoverished and homeless provincial girl, she also honored the memory of her mother, Marie, as well as the Virgin Mary.

With her striking beauty and rapidly improving social skills, Marie Duplessis quickly ascended the social ladder of the Parisian elite—changing each benefactor for a better one, while managing to remain in the good graces of most of them. They spent lavishly on her, and Marie in turn spent with abandon on clothes, horses, travel and furnishings. She also bought books and taught herself to write. From aristocrats to diplomats—young and old, single and married—no man could resist her

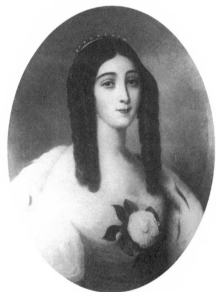

Marie Duplessis by
Édouard Viénot

charms, which were more than skin deep. Even though she developed the veneer of high society, she knew the streets as well. She was well-spoken and dressed like a high-society woman, but she also smoked, drank and danced in a way that proper ladies of her time never would. She was delicately feminine yet a prolific gambler. She had an angelic face and could discuss politics with the most educated men in Europe.

Among her many affairs, one inspired what would become her claim to immortality. In 1842, 18-year-old

Marie met the young Alexandre Dumas, who was an illegitimate child of cerebrated French author Alexandre Dumas and a laundress. Two years later, the two began an affair. Marie was already famous and enjoyed a luxurious lifestyle provided by her benefactors. Dumas was struggling to make money and forge his own destiny as a writer in the shadow of his illustrious father. The affair only lasted a year. Dumas managed to talk Duplessis into running away from Paris to the countryside with him for a short while, but she became bored and returned to Paris. Already bitter because he couldn't afford to provide the lifestyle she desired, Dumas also suffered when he watched her fall passionately in love with another artist, the Hungarian composer Franz Liszt. Marie pleaded with Liszt to take her with him on his world tour just as her health began to deteriorate due to tuberculosis (an all too common and tragic illness at the time known as "consumption"). Liszt declined and left Paris. He never saw her again.

Shortly after, Marie Duplessis succumbed to the disease. She spent the final years of her life desperately trying to get cured, while her benefactors left her one by one and her debts mounted. She died in 1847 at 23.

Her untimely death inspired Dumas, still reeling from the loss of his muse to another man, to write a novel entitled *La Dame aux Camélias* (*The Lady of the Camellias*

in English). In it, Dumas the writer achieved in fiction what Dumas the lover couldn't in real life: He got the woman he so desperately desired to love him wholeheartedly and to sacrifice herself for his benefit. In the novel, a courtesan named Marguerite Gautier gives up her lifestyle and runs away to the countryside with her young lover, Armand Duval, a character Dumas based on himself. Eventually, Duval's father finds the lovers and pleads with Marguerite to leave Duval so that the illicit affair won't damage their noble family name. Convinced by the pleas of her lover's family, Marguerite sacrifices her true love by leaving young Duval, never telling him why, and dies from consumption, tragically alone.

The love story of a nobleman and "a whore with a heart of gold" both scandalized and touched the public. While the first book of poems by Dumas sold only 14 copies, *La Dame aux Camélias* became an overnight sensation, selling out the first and second printings. The play based on the novel received an even bigger response—after a sold-out run in Paris, over 20,000 printed copies of the play were sold overnight. At first, actresses rejected the role of Marguerite due to the scandalous nature of her profession. But it quickly became one of the most coveted female roles in theater and was performed by the world's leading actresses in various adaptations, most famously by the great Sarah Bernhardt, who played Mar-

Maria Callas as Violetta in
La Traviata, ca. 1958

guerite in Paris, London and on Broadway. Although his real affair with Marie Duplessis had been short-lived, the success of *La Dame aux Camélias* inspired by their relationship propelled Dumas the son out of the shadow of his father.

In turn, the passionately written play provided inspiration for another great artist. After seeing the play in Paris, Italian composer Giuseppe Verdi created his most famous opera, *La Traviata* (Italian for "fallen woman"). Combined with Verdi's moving music, the story of the

courtesan sacrificing her love for the sake of her noble lover's future was transformed into an emotional experience. *La Traviata* debuted in 1853 in Venice, followed by performances in 1856 in New York and Paris, and was immediately recognized as Verdi's best work. *La Traviata* is now one of the most frequently performed operas worldwide and a cornerstone of operatic culture. There is hardly a night when *La Traviata* is not staged somewhere in the world. The title role of Violetta has been performed by some of the most renowned sopranos in history, including Maria Callas and Anna Netrebko. Its melodies are widely used in countless TV ads and easily recognized even by those who have never stepped inside an opera house. The drinking song, "Libiamo," an aria performed by the heroine surrounded by her men, is a toast calling for celebrating life in the present moment and was recently used in a TV ad for Heineken.

The story was also eagerly embraced by Hollywood—starting with the 1936 movie *Camille* based on the novel and the play by Dumas, with Greta Garbo playing Marguerite. This is considered one of Garbo's finest screen performances. The film was included in Time magazine's All-Time 100 Movies in 2005. More than 20 other film adaptations have been produced over the years in France, Italy, Denmark, Spain, Mexico, Argentina, Egypt, Turkey and Poland.

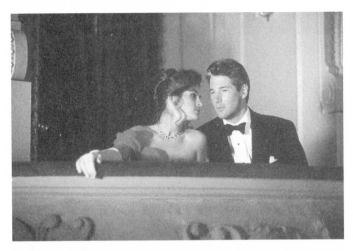

Pretty Woman, 1990

Many decades after the initial success of *Camille*, the story of a prostitute whose life turns around when she finds true love became the plot for *Pretty Woman*. Although the original script was much darker (it was titled *$3000*), the rights were eventually obtained by Disney, and the story was rewritten. In this reincarnation, directed by longtime industry veteran Garry Marshall, the girl neither renounces her love nor dies tragically. Instead, she challenges her rich benefactor to become a better person, quits her dishonorable profession and refuses to accept anything less than a fairy-tale love, which in the end he professes, showing up beneath her window like a knight

on a white horse. The film nods to its source material in one of its most memorable scenes when the rich client, played by Richard Gere, takes Julia Roberts' character to the opera, and she cries listening to the woman onstage spilling out her heart. The opera is *La Traviata*.

Pretty Woman was an enormous commercial success and made Julia Roberts a bona fide movie star. She was nominated for an Oscar and won a Golden Globe, and was transformed from a largely unknown, inexperienced actress into the highest-paid actress in the world.

Shortly before Marie Duplessis died of consumption, she told her maid, "I've always felt that I'll come back to life." She has—in some of the world's most inspired works of literature, theater, music and film.

3

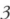

*"Everywhere and always, ugliness has its
beautiful aspects; it is thrilling to discover
them where nobody else has noticed them."*

—Henri Toulouse-Lautrec

HENRI DE TOULOUSE-LAUTREC

LIFE ON THE FRINGE

Inspired by his outsider status, the artist found unlikely models in the bar patrons and prostitutes of Montmartre. His drawings, portraits and lithographs are now the most recognizable images of the Belle Epoque in Paris in the 1890s.

I n November 1864, Henri Marie Raymond de Toulouse-Lautrec-Monfa was born in the city of Albi in southern France into wealth and privilege—but it was a deceptive beginning.

His parents, Alphonse and Adèle, were first cousins from a noble French family with a long history of inbreeding. His younger

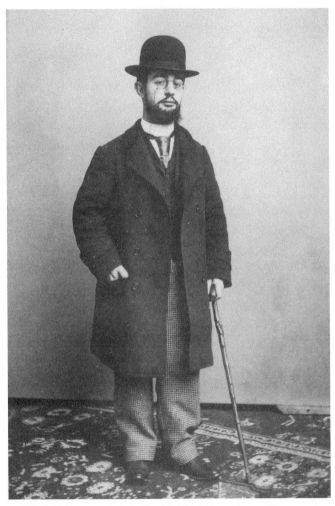

Henri de Toulouse-Lautrec, ca. 1895

brother didn't survive infancy, while Henri suffered from a medical condition that caused his left thighbone to fracture when he was 13 and his right one to do the same the following year. Neither healed properly afterward, so Lautrec grew up to be only 4 feet 11 inches tall with an adult body on the legs of a boy and hypertrophied genitals. The usual activities of the nobility—sports and horseback riding—were out of the question for him, so the boy immersed himself in art.

When Henri and his mother moved to Paris in 1872, he was only 8. The city, teeming with striking characters, dazzled the boy. He spent years studying art formally with his mother's assistance. In the 1880s, Lautrec discovered the bohemian village of Montmartre, filled with music halls, cabarets, art galleries, theaters, cafes and brothels. Sitting atop a hill above the rest of Paris, Montmartre was a world unto itself. It had something for everyone: rich and poor, artists and entrepreneurs, tourists and intellectuals, the classically inclined and the avant-garde. It was progressive and sinful. Prostitution was booming. And all of it was fueled by liquor, especially by the Parisian specialty, absinthe—"the green fairy"—favored by artists and writers for its alleged hallucinogenic properties.

Compared to the stifled atmosphere of his French provincial childhood and to the relatively rigid and rules-

driven society of Paris, Montmartre was a wild circus—and Lautrec fit right in. There, nobody cared that he was a dwarf, or that he liked posing for photographs in exotic costumes—in drag or as a Japanese priest holding a doll. Montmartre took him in unequivocally, and Lautrec dedicated his talent to its denizens.

The brothels of Montmartre embraced him; he was gregarious, witty and outgoing, drank heavily and spent money on women with abandon. The prostitutes took him in as their own, and he began documenting their life behind the scenes as well as their interactions with clients. One of Lautrec's subjects, Jane Avril, said of his relationships with prostitutes: "They were his friends as well as his models. In his presence they were just women, and he treated them as equals." Lautrec explained to an acquaintance that prostitutes made the best models because they were much more relaxed and less self-aware than his high-society friends and family members. That shared intimacy resulted in paintings and sketches that were strangely asexual considering the subject matter. Lautrec chose instead to highlight the exasperation and humiliation of prostitution: the solemn faces of women waiting for their clients in a cafe; their slumped postures while standing in line, half-naked, for a mandatory medical examination; a naked woman on all fours on a disheveled bed, staring into space without any emotion

like a horse in a barn. In a decade, Lautrec produced more than 50 paintings on the subject, none of which was publicly exhibited during his lifetime, except *Elles*, his 1896 album of 11 color lithographs depicting daily routines in the brothel.

Lautrec didn't have much support for his art among his peers. He admired the work of Degas—an older artist who also portrayed the demimonde—for his innovative framing, lighting and composition. One evening, after hosting a lavish dinner party, Lautrec invited his guests out for dessert. Rather than treating them to sweets, he escorted them to a neighbor's apartment for a private viewing of Degas' work. Degas did not reciprocate Lautrec's admiration, saying of Lautrec's studies of women in brothels that they "stank of syphilis."

Fueled by alcohol and with few social prospects other than living his eccentric image to the fullest, Lautrec eventually abandoned any self-censorship. At one point, he started keeping cormorants as pets, often letting one of his birds waddle behind him on the street and into a bar, where the two shared a glass of absinthe that Lautrec said the bird had "developed the taste for." Sometimes, Lautrec would throw dinner parties at his studio that were more performance art than gastronomical feasts, like the time he decided to prepare marsupial meat after seeing a boxing kangaroo in a circus. When he couldn't

find kangaroo meat in Paris, he asked the butcher to sew a pouch onto a chunk of mutton. Lautrec paid just as much creative attention to his drinking: He invented a cocktail appropriately called the Earthquake—a mix of absinthe and cognac—and hollowed out his walking stick so it could contain a glass tube for liquor.

Lautrec's aristocratic family was outraged at his lifestyle. His father partly disinherited him, not only because of his body of work but also his insistence on making money by actually working, which he thought was unbecoming of their noble lineage. An uncle burned several of his paintings in the family courtyard in front of witnesses. His mother was the only one who kept in touch and continued to support him from a distance.

By 1888, Lautrec had made a name for himself, and when the Moulin Rouge opened in Montmartre the following year, one of his circus paintings graced the entrance hall. The cabaret quickly gained popularity for its programming, which was risqué even for Paris. In fact, police started visiting the Moulin Rouge to make sure its cancan dancers were wearing underwear—which more often than not they weren't. The Moulin Rouge became a refuge for Lautrec—he had a table and an uninterrupted flow of drinks there, while the shows kept him entertained and provided new subjects. Among his many obsessions, he found an inspiring muse in Mademoi-

selle Cha-u-Kao, the clowness of Moulin Rouge. There couldn't have been a more appealing subject for Lautrec. Her name was an amalgam of "cancan" and "chaos;" she was a female clown and acrobat in a predominantly male field; she was openly gay but worked part time as a courtesan. Yet, what Lautrec focused on in his portraits of Cha-u-Kao was her humanity over her exotic persona. Lautrec's portrait of her, *The Seated Clowness,* shows an exhausted middle-aged woman trying to catch her breath backstage while the show carries on behind her.

Two years into its run, the owner of the Moulin Rouge commissioned Lautrec to create a special poster promoting the cabaret. Lautrec focused on its star dancer Louise Weber, known as the Queen of Montmartre for her audacious behavior, like kicking the patrons' top hats off with her toe and downing the customers' glasses while dancing past their tables, for which the adoring public called her "La Goulue" (the Glutton). Lautrec sketched her in a simplified silhouette, influenced by Japanese art, her leg kicking high up above one of the spectators—a soulless gray male figure in a top hat. This was Lautrec's first foray into using recently developed color lithography—a technique in which the image is drawn on a limestone plate, then inked and printed in large quantities. Because the technique was less than accurate, some art critics dismissed it as yet another of Lautrec's gim-

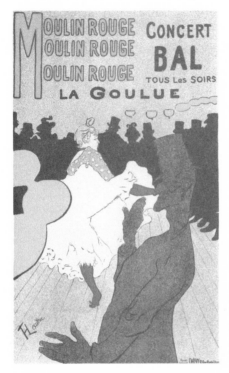

Henri de Toulouse-Lautrec,
Moulin Rouge La Goulue,
1891

micks. In late 1891, some 3,000 copies of the poster appeared on walls around Paris. Other posters and prints by Lautrec followed, featuring Jane Avril, Aristide Bruant, Yvette Guilbert and other Moulin Rouge celebrities. Because of their originality, Lautrec's eye-catching posters were so popular that Parisians followed the workmen

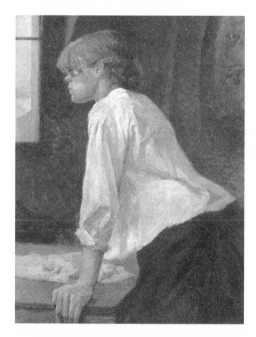

Henri de Toulouse-Lautrec, *The Laundress*, 1886-87

hanging them so they could peel them off the walls before the glue had dried.

Toward the end of Lautrec's life, hallucinations and paranoia, induced by alcoholism and syphilis, overwhelmed him. Once, when he was visiting friends in the country, they heard a shot from his room, and found him sitting on his bed with a pistol, claiming that spiders were attacking him. He was sent to an asylum at Neuilly,

where he produced a series of circus drawings from memory hoping to convince his doctors that he was still sane. The drawings worked, and he was released.

Home from the asylum, Lautrec began drinking again. He spent his last days in his mother's Château Malromé, where he died in her arms in 1901, just shy of his 37th birthday. His final words, a comment on the presence of his father at his deathbed, were "the old fool."

Once called "a caricature" and a "counterfeit artist" by a critic, Lautrec left behind 737 canvases, 275 watercolors, 368 prints and posters, and 5,084 drawings. His works are now regarded as innovative for the way in which they captured Paris in the late-19th century. Lautrec's work is exhibited in both the Louvre and the Musée d'Orsay, as well as in the museum in his hometown of Albi. His posters for the Moulin Rouge and other Paris establishments elevated advertising to art. His art is among the most reproduced, recognized and respected in the world. In 2005, Lautrec's painting *The Laundress* (1886-87), depicting a young woman named Carmen Gaudin—part-time model, part-time prostitute and part-time washerwoman—looking longingly out of a window, sold at Christie's in New York for $22.4 million, setting a new record for the artist and assuring his place as the embodiment of Paris' artistic spirit.

4

"Yes. It is true. You are indeed one of us."

—Degas to Valadon

SUZANNE VALADON

A Muse Turned Artist

Inspired by her time posing for the great artists of Paris, a model taught herself to draw and paint, and created a vast body of work in her own bold style, while continuing to serve as a muse to others.

When posing as an artist's model for the first time, 16-year-old Marie-Clémentine Valadon thought to herself, "This is it! This is it!" She knew: Montmartre was the place for her, the place she should never leave. The teenage Marie-Clémentine, born a poor illegitimate child with no

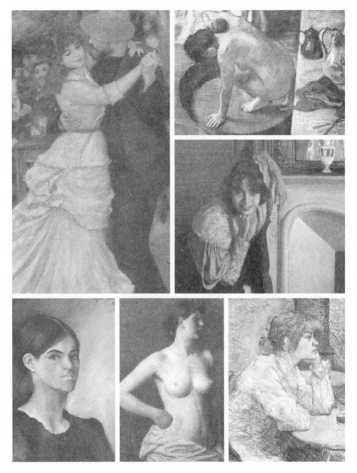

Suzanne Valadon (clockwise from top left):
Pierre-Auguste Renoir, 1883; Edgar Degas, 1886;
Santiago Rusiñol, 1894; Henri de Toulouse-Lautrec,
1887-1889; Pierre Puvis de Chavannes, 1880; self-
portrait, 1883

education and no prospects, suddenly felt she had found her destiny in bohemian Montmartre, at the center of the artists' universe in Paris.

Like many other girls of her social class, Valadon had worked every possible job in her teens—from milliner to waitress to vegetable seller to funeral wreath maker. She attended a convent school for only a few years. By 15, she was working as a tightrope walker in a circus. When she was injured after falling from a trapeze, a friend suggested she try to get work as an artist's model. Despite her mother's fears that modeling could lead her to become an artist's mistress, Valadon gathered with other hopeful young women at Place Pigalle in the heart of Paris to wait to be chosen. With her pale skin, cognac-colored hair, blue eyes and figure transforming from angelic adolescent to striking young woman, she was just what the artists were looking for.

Her mother's fears came true: As soon as she became a model, the affairs began. In the famously loose universe of Montmartre during the Belle Époque, male artists felt it was their right to seduce their models. At 17, Valadon moved in with 57-year-old painter Pierre Puvis de Chavannes. Six months later, she went back to living with her mother. She continued modeling for, and became lovers with, a series of artists, including Renoir. At 18, she gave birth to a son she named Maurice. Vala-

don reached out to all the painters she had modeled for, as several of them could have been the father. Eventually, the Spanish painter Miguel Utrillo claimed paternity, and her son took the artist's name.

Something else was happening, unnoticed by most: While posing for the great painters around her, Valadon quietly studied their craft. She started painting on her own. Her lack of formal training kept her from imitating the techniques developed by others. Her subject became the one she knew best—the female body. Unlike the romanticized, sexualized female portraits created by male artists all around her, Valadon painted her strikingly unflattering nudes in crude lines and vivid colors. She also painted herself. Her second painting was a self-portrait, titled *Portrait of the Artist* and signed with her modeling name Suzanne Valadon. Quietly, Valadon became an unheard-of phenomenon in the male-dominated art world: a woman who was both a model and an artist herself.

Soon after giving birth, Valadon went back to work and placed her son in the care of his grandmother. Maurice was growing up troubled, with frequent and intense fits of rage. By age 16, he was an alcoholic who exhibited signs of mental illness. Valadon sent him to an asylum, where a doctor suggested that painting might be therapeutic. Valadon taught him what she knew as an artist,

Suzanne Valadon

and Maurice showed real talent, whether taking after his unknown artist father or Valadon herself.

Most in Montmartre, however, did not take her talent seriously. Although Valadon had posed for Renoir, he did not encourage his onetime muse's attempts at drawing. In a letter to a friend, the artist remarked: "I think of women who are writers, lawyers and politicians as monsters, mere freaks...the woman artist is just ridiculous." Many other male artists and critics agreed. A female artist painting female nudes was unacceptable, and her style was beyond classification. Her art troubled the Mont-

martre establishment. Her figures were criticized as being "coarse" and the female subjects as "obviously of the lower classes."

Valadon got a different response from a neighbor, an artist and an outsider himself—Henri de Toulouse-Lautrec. It was Lautrec who renamed her Suzanne, after the biblical story of Susanna and the Elders, in which a young woman is falsely accused by scheming older men of promiscuity, in order to blackmail her into submitting to their carnal desires. Lautrec and Valadon became close friends. Lautrec would often invite her to his studio to critique something he had created, as he respected her opinion as an artist. Always eager to challenge the mind-sets of the mainstream art world, Lautrec bought a couple of her earlier drawings and invited his refined friends to identify the artist. No one could guess correctly, trying to decide if it was work by Degas or even Rodin. But everyone agreed it was by an artist of incredible natural talent, one who followed nobody eles's style. The great Degas himself was stunned when he saw his former model's work and started buying her pieces very early on. "You are, indeed, one of us," he told Valadon. In 1894, Suzanne Valadon became the first woman to exhibit her paintings at the Société Nationale des Beaux-Arts, a serious accomplishment for any artist, let alone a female painter. Many other exhibits followed.

In 1896, Valadon married stockbroker Paul Moussis in an attempt to settle down. Thanks to the financial security of her marriage, Valadon was free to concentrate on her art. Except, Moussis couldn't deal with the consequences of Maurice's alcoholism, and Valadon was too much of a free spirit to lead a "normal" life. She missed the energy of Montmartre. The marriage didn't last, and Valadon found herself in the arms of a handsome friend of her son, the painter André Utter, who was 20 years her junior. Valadon, Maurice (by then an established artist in his own right) and Utter set up a studio together, becoming an endless source of gossip throughout Montmartre, which was fascinated with their personal relationships more than their art. They became known as the "trinité maudite" (terrible trio).

Valadon's relationship with Utter became her greatest inspiration. Her previous affairs had been with older men, not so much romantic as practical: a way to make a living. This was different. Utter was passionate about her as a woman and admired her as an artist. The relationship inspired Valadon to create *Adam and Eve* (1909), one of her best-known works. The painting was the first publicly exhibited depiction of a nude man and woman together by a female artist. The concept was daring—Adam and Eve unabashedly nude and running toward the viewer. The figure of Eve was a self-portrait, with Utter posing

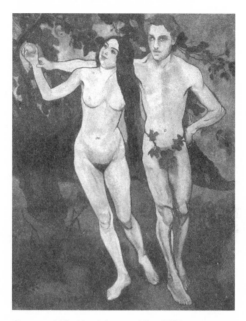

Suzanne Valadon, *Adam and Eve*, 1909

as Adam. Eve appears completely nude, while the fig leaf covering Adam was only added later to allow the painting to be displayed in public. Utter also modeled for the figures of three male nudes in *Casting the Net* (1914), which shows three beautifully sculpted young males from various angles. Valadon broke the unspoken rule: While it was acceptable for male artists to depict nude women in various poses, showing a nude male in such a provocative manner—and by a female artist—was a bold move.

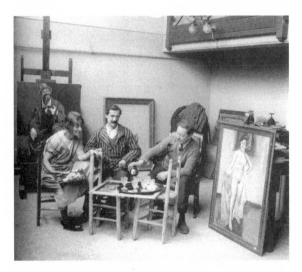

Suzanne Valadon, Maurice Utrillo and André Utter, 1926

By 1909, Valadon was so successful as an artist, she was able to support herself and her unconventional family with her artwork alone. Through her marriage to Utter, Valadon also met artists of the next generation, like Picasso, Modigliani and Braque. Both Maurice and Suzanne continued to develop their unique painting styles. Eventually, both Valadon and her son were able to afford a chateau near Lyon. As Valadon aged, Utter started spending more time with mistresses. The relationship deteriorated, but Utter kept his connection with her in order to benefit from the sale of her and her son's work.

As Valadon matured, her art changed, too. Her subject matter became more realistic and earthy—showcasing voluptuous flowers, fruit in bowls and her cat sprawled on cushions—a contrast to the more feminine and stylized art that was in vogue at the time. In 1923, she accepted the changes she was going through by painting a stark self-portrait: aging, naked and vulnerable. It was an unflinching look by Valadon, the artist, at Valadon, the model and the muse.

In 1938, Valadon died of a stroke at 73 years old while painting at her easel. Her burial was attended by many great artists of Montmartre, from Picasso to Braque. Her obituary in Le Figaro mentioned that she was the wife of painter André Utter and mother of painter Maurice Utrillo, but not that she was an artist herself.

Shortly before she died, Valadon said, "My work… is finished and the only satisfaction I gain from it is that I have never surrendered. I have never betrayed anything I believed in." She produced 273 drawings, 31 etchings and 478 paintings—not counting the ones destroyed by Utter and her dogs or simply given away.

Critics now recognize the uniqueness of Valadon's style and her raw, natural talent—neither indebted to nor influenced by any of her contemporaries. Her paintings and drawings are in the permanent collections of many museums, including The Metropolitan Museum of Art

in New York and the Centre Pompidou in Paris. An asteroid and a crater on Venus were also named after the stellar muse of Montmartre.

Suzanne Valadon remains one of the rarest figures in the history of art: a muse and an artist in one.

5

"You are not alive unless you know you are living."

—*Amedeo Modigliani*

MODIGLIANI AND HÉBUTERNE

THE LOST HOPE

Inspired by his impending death, the reckless, ailing artist destroyed the life of his selfless young muse—and immortalized her in his art.

There were many legendary artists in 1920s Paris, but Amedeo Modigliani is perhaps the most tragic, because of how he lived and what he could have achieved had he not been so inspired by his imminent death.

Modigliani's life was a roller coaster from the very start. He was born in 1884 in the port city of Livorno, Italy, into a mixed Italian and Jewish family that had been very well off, but

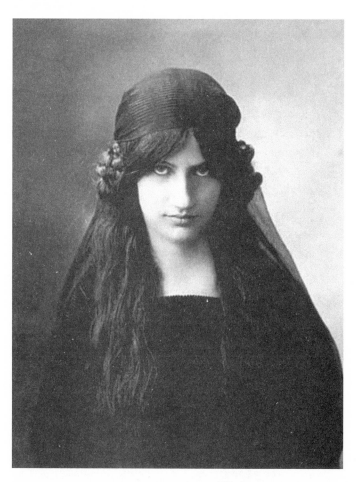

Jeanne Hébuterne

went bankrupt just a week before. It was his birth that saved the family. What little they managed to throw together was hidden under his mother's bed, and debt collectors were prohibited by law from seizing the bed of a woman who has just given birth. Modigliani showed artistic talent from an early age, but he was a sickly child. Contracting pleurisy at 10 and typhoid fever a few years later, Modigliani was beset by health problems. While he was able to travel all over Italy with his mother to view Renaissance art and was accepted to study under a renowned painting master, he received a death sentence at the age of 16 when he contracted tuberculosis. Called the "white plague," tuberculosis was highly contagious, widespread and untreatable at the time; four out of five carriers died from it.

At 19, Modigliani was accepted into the Istituto di Belle Arti in Venice, where he excelled. But he had already set his mind on not living long. He was an avid reader and took to heart the much discussed writings of German philosopher Friedrich Nietzsche, who advocated that God is dead and that the morality of common people favors mediocrity. Modigliani resolved to achieve maximum creative power by pursuing every stimulating experience available to him in whatever time he had left to live. While studying in Venice, he started smoking hashish and became a regular in the seedy establishments

of Venice's back alleys.

What he didn't know was that his was not the only life that would be cut short.

Jeanne Hébuterne was born in 1898 into a respectable Parisian family. In 1906, Jeanne turned 8 and was enjoying a happy childhood with her adoring bourgeois Catholic family, when 22-year-old Modigliani moved to the artist enclave of Le Bateau-Lavoir in Montmartre just a mile away.

Within a year, Modigliani became an alcoholic and drug addict. One night, in a moment of rage, he destroyed everything he had created, calling these works childish, and started again from scratch. Painfully jealous of Picasso and other acknowledged artists in his Parisian circles, he feverishly searched for his own unique style.

Deciding to dedicate himself fully to art, Modigliani shed all vestiges of his cultivated upbringing, no longer wasting time on keeping up appearances, caring about money or observing etiquette. At times, he resorted to exchanging paintings for meals. A food seller on a street corner would accept his paintings as payment and then use them to wrap potato chips for customers. Sometimes, Modigliani slept in train stations or abandoned buildings. Sometimes, he would get drunk and strip naked at parties. The police repeatedly detained him when they broke up drunken brawls with him at their

center. It was too much even for the bohemians of Montmartre. They started calling him "Modi"—a nickname that sounded like "cursed" in French *(maudit)*. Modigliani wasn't insulted by the new name, telling his friend, sculptor Jacques Lipchitz, that all he wanted was "*une vie brève mais intense*," a brief but intense life. He continued indulging in absinthe, hashish and endless affairs, all of which inspired him to create.

In 1917, 19-year-old Jeanne, dreaming of becoming an artist, enrolled in Académie Colarossi in Montparnasse. One day, Jeanne, with her long thick hair, pale skin and intense gaze, was modeling for an artist when Modigliani showed up at the academy looking for new models. The two saw each other, and an invisible clock started ticking: They had a grand love affair ahead of them, and only three years left to live.

Jeanne's family was dismayed when she promptly moved in with Modigliani in his crumbling apartment. He was destitute, Jewish, much older than she, and his first and only exhibit had been shut down by the police because of his scandalous nude paintings. Her strict father disowned her, but her heartbroken mother continued to sneak money to her whenever she could.

Unlike his previous lovers, Jeanne was the woman Modigliani planned to marry. He painted many portraits of her in what had become his signature style: elongated

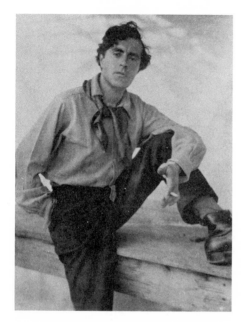

Amedeo Modigliani

head; long, fluid neck; enlarged eyes full of emotion—all in subdued colors. He never painted her in the nude. When he wasn't painting, he was spending nights in the cafes, trying to kill the shame of being a nobody and the pain of tuberculosis by heavy drinking and smoking hashish, coughing for hours afterward. Pregnant with their first child, Jeanne often came to drag him home, pleading with him to stop killing himself.

When Jeanne gave birth to a daughter, she named her Jeanne and gave the baby her own last name, Hébuterne. Modigliani intended to register the child as his, but got drunk and never made it to the registrar's office, leaving his daughter fatherless on paper for the rest of her life. He never filed for a marriage license, either.

In 1919, Jeanne was pregnant again, when Modigliani finally got some recognition. The art community began admiring his unique style. Art dealers circled around. A friend—poet, writer and art dealer Leopold Zborowski—helped organize an art show in London at the Mansard Gallery, exhibiting work by Picasso, Matisse and several other Parisian artists. The London media singled out Modigliani as having the most unique style, and the highest price was paid for his painting. Modigliani was ecstatic, but the joy was short-lived. His career had turned a corner in London, but nobody noticed in Paris.

Modigliani gave up. His tuberculosis, accelerated by years of poverty and bad habits, consumed what was left of his health. On a cold January morning in 1920, friends came to check on him after not seeing him in the bars for several days. They found him barely breathing, slumped on the floor of his unheated studio and surrounded by empty wine bottles and sardine cans. Jeanne was sitting next to him, trying to paint his portrait, the canvas propped on her pregnant belly, her face frozen

into a mask of madness. The friends managed to carry Modigliani to a charity hospital, Hôpital de la Charité, where he died within hours. He was 35. The first successful testing of a tuberculosis vaccine on humans commenced in Paris just a year later.

Jeanne's parents took her home, where the nine-month-pregnant woman threw herself out of the fifth-floor window. She died instantly along with her unborn baby, leaving her only surviving child, 14-month-old Jeanne, an orphan.

Modigliani's funeral was a mob scene: Every artist in Paris came to pay his respects, and dealers rushed in to secure his paintings before they soared in price. Even the police who shut down his first exhibit years before jumped into the game. But the Modigliani family, including his beloved mother, did not benefit from his posthumous fame: They didn't own any of his paintings.

As to Jeanne and Amedeo's orphaned daughter, both the Modigliani and Hébuterne families brought her up in Italy and Paris, where she studied her father's artistic legacy and her parents' union. In 1958, she published a comprehensive biography, *Modigliani, Man and Myth*. She lived to be 66.

The tragic love story of Jeanne Hébuterne and Amedeo Modigliani has been immortalized in literature and the movies. Four years after their deaths, novelist

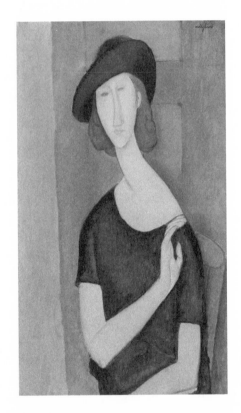

Amedeo Modigliani,
*Jeanne Hébuterne
(au Chapeau)*, 1919

Michel Georges-Michel wrote *Les Montparnos*, which he later adapted into the 1958 film *Modigliani of Montparnasse*, directed by Jacques Becker and starring Gérard Philipe as Modigliani and Anouk Aimée as Hébuterne. In the most recent biopic, 2004's *Modigliani*, Andy Garcia played the artist.

At a 2013 auction at Christie's in London, Modigliani's portrait of Jeanne in a hat from their happier days—*Jeanne Hébuterne (au Chapeau)*—sold for $42 million. Modigliani's artworks are now exhibited in major museums around the world and are valued equally to those by his one-time rival Picasso, whose artistic career lasted six decades longer.

The question remains: What would the world of art have gained—or lost—if the tuberculosis vaccine had been invented sooner?

6

*"I am a woman who enjoys herself very much;
sometimes I lose, sometimes I win."*

*—Margaretha Zelle MacLeod,
a.k.a. Mata Hari*

MATA HARI

THE ACCIDENTAL FEMME FATALE

Inspired by her search for love and adventure, Margaretha Zelle reinvented herself as exotic seductress Mata Hari, who was accused of and executed for being a double agent, becoming the most famous femme fatale in modern history.

There is hardly an archetype more intriguing than that of the femme fatale: a beautiful, unscrupulous woman skilled in the art of seduction, who manipulates men to achieve her goals. The most famous of them all, Mata Hari, is remembered as an Indonesian erotic dancer and a cunning double agent, who

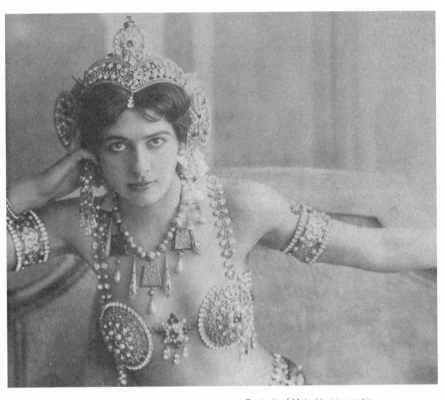

Portrait of Mata Hari in exotic
costume, 1906

seduced many powerful men on all sides of World War I, allegedly to gather military intelligence, until she was arrested and executed for treason by the French in 1917.

But Mata Hari wasn't actually Indonesian; she wasn't that skillful as a dancer; and, as it turns out, she was not an effective spy, either. She was, however, a talented, if lonely, woman in constant search of love and adventure.

Mata Hari was born Margaretha Zelle in 1876 into a well-off family in the Dutch town of Leeuwarden. The family lived lavishly, and her father doted on her—until he went bankrupt. Her parents soon divorced, and her mother died when Margaretha was just 15. After her father remarried, the teenager was no longer the center of his attention and was sent away to school to become a kindergarten teacher. It was there that the 16-year-old tried to fill the void by having an affair with the headmaster, who was 51 and married. Whether the teacher or student was the seducer remains unknown, but Margaretha was shunned by her family and expelled from the school.

There was not much left for Margaretha in her hometown, so she fled to The Hague, a big city that offered the chance of a new life and, perhaps, the real love she craved. Soon, the 18-year-old answered a newspaper advertisement placed by a Dutch officer, Captain Rudolph MacLeod, of noble Scottish lineage stationed on the opposite side of the world in Java (Indonesia),

an exotic and rich outpost of the Dutch empire. He was looking for a wife. The two wrote passionate letters to each other for months until they met in Holland. Young Margaretha was smitten by the distinguished-looking officer 20 years her senior. He called her "my angel" and promised he would love and protect her.

Excited about the prospect of an exotic life and in love with her new husband, Margaretha sailed halfway around the world to Indonesia, where all her hopes were quickly crushed. MacLeod turned out to be a heavy drinker; he had a bad temper; and, to her dismay, was involved with a local housemaid who also served as his guide into Indonesian culture, a customary arrangement for most Dutch officers at the time. Margaretha took refuge in studying the local dances and culture, and began an affair of her own with another Dutch officer. The latter, however, insulted MacLeod's noble family name, so the captain convinced her to return to him. She did, but the couple's two young children fell gravely ill shortly afterward. Some accounts say it was due to complications from syphilis contracted from the parents. Another theory blames it on food poisoning arranged by an enemy of the captain's. The couple's 2-year-old son died, but their daughter survived. Embittered and quarreling, they returned to Holland and divorced. MacLeod refused to pay alimony, but gave custody of their daughter to Marga-

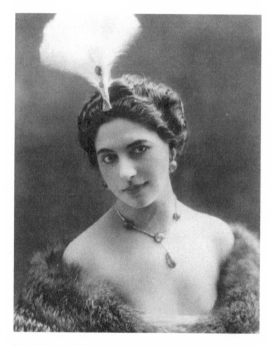

Mata Hari, ca. 1900

retha, until he changed his mind and took the child away. Margaretha found herself back where she had started: alone, unloved, with no means of support. Therefore, she did what she knew best: She began again.

In 1903, Margaretha landed in Paris. Lacking any real skills or education, she posed as a model for artists

and rode a horse in a circus under the name of Lady Mac Leod, a career path that did not sit well with the Mac Leod clan. So, by 1905, Margaretha decided to reinvent herself. Putting together what few assets she had (a tanned skin, a basic knowledge of Indonesian culture and Parisian high society's obsession with all things Oriental), she created the character of Mata Hari (Malay for "Eye of Day," meaning sun).

Tall and dark-haired, she presented herself at the salons of Paris as an exotic Javan princess, allegedly born into a high Hindu caste, where she had been taught sacred Hindu rituals. Mata Hari began choreographing and performing dance routines, loosely based on those she studied in Indonesia—nearly nude except for skimpy costumes consisting of jeweled bras, a thin body stocking and sheer veils she shed onstage. Her dancing skills were negligible, but her allure was undeniable. She looked exotic, spoke several languages and was uninhibited onstage. Paris was enthralled.

After her performance based on the play *Salome* by Oscar Wilde, Mata Hari's image as an exotic seductress was set. In this sexualized version of the biblical story, Salome, who was known for her hypnotic dancing skills, asks of her stepfather Herod Antipas—and receives as a reward—the head of John the Baptist in exchange for performing the dance of the seven veils.

Mata Hari hypnotized the public both onstage and off, blurring the line between performer and high-society courtesan. The endless lineup of her lovers included the most influential men of Europe, from Italian composer Giacomo Puccini to French philanthropist and entrepreneur Baron Henri de Rothschild, from international law expert Édouard Clunet to the French minister of war General Adolphe-Pierre Messimy and many other high-ranking diplomats. After spending time in Germany, she claimed to have had an affair with Crown Prince Wilhelm himself.

She shamelessly relied on her lovers for money. Felix Rousseau, a successful married banker, became her chief patron for several years, buying her an expensive villa in the fashionable Parisian suburb of Neuilly and nearly bankrupting himself in the process. For a number of years, Mata Hari was involved with a wealthy German cavalry officer, Alfred Kiepert, who succumbed to family pressure to pay her off with an enormous sum of money that she accepted with no qualms.

While Mata Hari traveled in pursuit of new adventures and generous lovers throughout Europe—Paris, Madrid, Rome, Vienna, Berlin—the ominous clouds of World War I were gathering above her head. The intelligence services of Germany, Britain and France began tracking her movements and diverse connections

across borders. She was under suspicion: She had too many relationships on every side of the map and traveled too much to be doing so solely for personal reasons. The French military took special offense at her lifestyle. She was condemned for allegedly bathing in milk while French soldiers starved on the battlefields, and traveling with trunks of richly decorated clothing across battle lines.

By 1914, Mata Hari's dancing career was over. She was gaining weight; she was almost 40; her lack of talent was becoming more obvious. And she was running out of money. She desperately needed cash. She was now in love with a dashing 21-year-old Russian captain, who was injured and needed her support. Without considering what would be required of her, she accepted money from a German consul who wanted her to spy on the French. She also agreed to spy for the French in exchange for a travel pass to a military secured zone, where the Russian was waiting for her.

The travel pass was never issued. The stars finally aligned against her. Suspecting her of spying for the Germans, the French gave her the names of six Belgian operatives thought to be double agents for Germany. When one of them was executed by the Germans shortly thereafter, it was used as evidence against Mata Hari.

Just a year into her "spy career," Mata Hari was ar-

rested in Paris. The French military tribunal deliberated for less than 45 minutes. The evidence against her was inconclusive at best, but since she was alarmingly "foreign" (sometimes even confused for a Russian), openly promiscuous (especially with prominent German officials) and outrageously unapologetic, she was the perfect scapegoat. Mata Hari was found guilty of spying for Germany, blamed for the deaths of 50,000 French troops and sentenced to death.

At dawn on Oct. 15, 1917, Mata Hari awoke at 5 a.m. in her cell in Prison Saint-Lazare and dressed in her best suit. She refused to make her last confession to a priest, saying that the only thing she ever did was love men. "Harlot, yes, but traitor, never!" she said. She also declined to wear the customary blindfold for the execution, never one to be just a passive character in a play. When she was brought to face the 12-man firing squad, she looked straight at the soldiers and blew them a kiss. As the sun—her namesake—was rising, they gunned her down. She was 41 years old.

Despite the many lovers who surrounded her in life, nobody wanted to claim her dead body, so it was used for medical research. Her embalmed head went to a Paris museum, from which it disappeared without a trace. It was as if Mata Hari dissolved back into the universe, leaving nothing behind but an enduring legend.

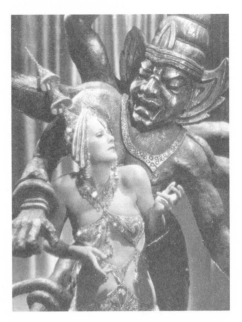

Mata Hari (1931), starring Greta Garbo

And the legend has never ceased to inspire. The first film about the famous seductress was the German silent movie *Mata Hari: The Red Dancer*, which came out in 1927, just 10 years after her execution. But it was the grand 1931 black-and-white Hollywood film *Mata Hari*, with Greta Garbo in the title role, that propelled the legend to new heights. A Swedish-born beauty with extraordinary screen presence, Garbo was a striking match to

the character of Mata Hari, since she was just as exotic for Americans as Mata Hari herself had been for Europeans. Lavishly designed and staged, complete with a tantalizing depiction of Mata Hari's dance of the seven veils, the biopic became a sensation on both sides of the Atlantic, solidifying the legend of Mata Hari and the Hollywood career of Greta Garbo. Many more movies and musicals have followed.

The allure of the femme fatale archetype continues to inspire writers and filmmakers. Beautiful but ruthless female spies appear in a wide range of hit movies, from the female villains and allies in the James Bond franchise to the title character in *Mr. and Mrs. Smith,* a mercenary played by Angelina Jolie, who abandons her assignment to kill when she falls in love with the "mark." In 2016, the Dutch National Ballet staged a large-scale production dedicated to Mata Hari, calling her "one of the most iconic women in Dutch history."

A century after the execution of Margaretha Zelle MacLeod, the legend of Mata Hari remains one of the most alluring stories in film and literature, even though she began as a character played by an adventurous woman desperately in search of love.

7

"I think of slaying Holmes . . . and winding him up for good and all."

—*Sir Arthur Conan Doyle,
letter to his mother, 1891*

SIR ARTHUR CONAN DOYLE

"SHERLOCK HOLMES MUST DIE"

Inspired by the unconventional personality of his professor, Sir Arthur Conan Doyle created the world's most beloved detective, Sherlock Holmes—and then wanted to kill him so he could turn to more distinguished literary work.

The world's most famous detective, Sherlock Holmes, had many adversaries: high-society villains, lowbrow gangsters, crooked doctors, vindictive ex-lovers. But nobody wanted to dispose of him more than Sherlock's own creator, Sir Arthur Conan Doyle.

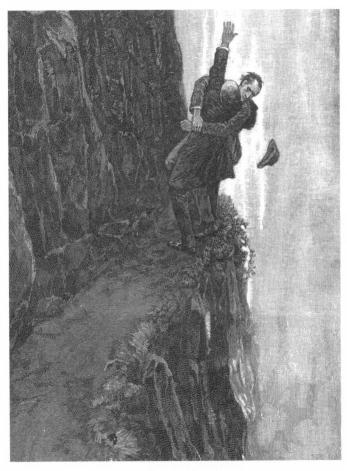

Holmes and Moriarty plunging to
their deaths at Reichenbach Falls

Sherlock Holmes was brought to life in 1886 by Arthur Conan Doyle, a young Scottish doctor with a failing medical practice, who decided to pursue his true passion, storytelling. The inspiration for the detective's forensic skills and deduction methods came from Doyle's memories of Dr. Joseph Bell, a pioneer of forensic science and a professor at the University of Edinburgh Medical School, where Doyle had studied. Dr. Bell was a prominent surgeon, forensic expert and a lecturer famous for his observational skills: He could diagnose a patient's health problems based on nothing but appearance; he could read sailor's tattoos as if they were passport stamps; and he could correctly ascertain that a woman he had just met had a second child at home in addition to the one with her.

Professor Bell also had a peculiar sense of humor. He liked to conduct an experiment in class—dipping his finger into a test tube containing an allegedly potent drug and then sucking it off his finger, asking his students to do the same in order to familiarize themselves with the drug's taste. After he watched the tube go around the lecture hall, he would explain that the finger he had dipped in the tube was not the same finger he put in his mouth, advising them to pay closer attention to every detail around them. In some versions of this story, the liquid in the test tube was Dr. Bell's own urine. Doyle borrowed

Dr. Joseph Bell (left) and Arthur Conan Doyle

Dr. Bell's dry sense of humor and cold demeanor to create Sherlock Holmes' unusual personality.

The first Sherlock Holmes novel, *A Study in Scarlet*, was published in 1887. Doyle only received £25 for it, but the public instantly fell for Sherlock Holmes and his dark romance with London. The first novel's success called for a sequel, *The Sign of the Four,* published in 1890. Sherlock Holmes quickly became the most famous Londoner who never lived. Nobody could have guessed that Doyle had so little knowledge of London while writing the first book that he relied on the London Post Office Directory to help him plot the trajectory of Holmes' investigations all over the city.

Doyle went on to write 23 more stories about Sherlock Holmes, published collectively as *The Adventures of Sherlock Holmes* and *The Memoirs of Sherlock Holmes* between 1892 and 1894. With every new publication, he sent a copy to Professor Bell who enjoyed his association with the famous detective, crediting Doyle's exceptional talent for storytelling for creating such a memorable character "out of very little."

In spite of its success, Doyle grew tired of his Sherlock Holmes series, considering it minor work. He contemplated finishing Sherlock off to free up his time to pursue what he considered more serious themes—historical novels about British imperial rule. When he told his mother about his plan in 1891, just four short years after the first Sherlock Holmes story was published, she vehemently objected, "You can't! You won't! You mustn't!" She suggested a plot twist, which helped delay Holmes' looming execution by his creator. Doyle then attempted to decrease publishers' interest in the series by hiking up his asking price, but publishers eagerly paid more. Doyle became the highest-paid author in Great Britain at the time—and the prisoner of his own success, growing ever more resentful of Holmes.

Doyle finally killed the detective in *The Final Problem*, published in 1893. By dropping Holmes into the abyss of Reichenbach Falls together with his most deadly

archenemy, Professor Moriarty, Doyle hoped to finally have the time to focus on other subjects, the ones that he believed would establish his more serious literary legacy.

It didn't sit well with the public. Doyle's mother was furious with him. An avalanche of hate letters came in the mail. Rabid fans hounded Doyle on the streets of London, and an angry woman attacked him with an umbrella in broad daylight. Grieving fans wore black armbands to mourn the detective's untimely death. The Strand magazine, which had been publishing the stories, lost 20,000 subscriptions and was plunged into bankruptcy, referring to the tragic death of Sherlock Holmes as "The Dreadful Event."

Doyle went on to write historical and nonfiction books. In 1902, the author was knighted by King Edward VII for his documentation of the Boer War in Africa, which he had witnessed firsthand in 1900 by volunteering as an army doctor—perhaps in an effort to escape the obsessed Holmes fans back in London. Doyle also wrote several non-Holmes novels and short stories during this time, known as "The Great Hiatus" to Sherlock Holmes fans.

After seven years of pressure from fans and publishers, Doyle relented and brought Sherlock Holmes back from the dead in 1902 in the spectacular The *Hound of the Baskervilles*. After resurrecting his most famous char-

acter, Doyle completed 33 more short stories collectively published as *The Return of Sherlock Holmes*, *His Last Bow* and *The Book-Case of Sherlock Holmes*, along with the novel *The Valley of Fear*. Professor Bell, always flattered that he had inspired such a famous character, sent Doyle a letter saying, "You are the Sherlock Holmes now."

Outside the world of Sherlock Holmes, Doyle, who was married twice and had five children, wrote seven historical novels, three books of poetry, five novels featuring Professor Challenger, (including the critically acclaimed *The Lost World*, the precursor to the *Jurassic Park* movie franchise), an operetta, a diary of his time as a ship's doctor in an Arctic expedition and numerous short stories. He was also an accomplished boxer, popularized skiing in Switzerland, was an avid soccer, golf and cricket player, and became the first person in Britain to receive a speeding ticket. Using the same investigative methods that he gave to Holmes, Doyle personally investigated two closed criminal cases resulting in the exoneration of both convicts, which contributed to the establishment of the Court of Criminal Appeal in 1907. He was also very interested in fairies, became a member of the Ghost Club and sought to prove existence beyond the grave. Yet to the world at large Doyle's legacy remains, first and foremost, as the creator—and the one-time murderer—of the inimitable Sherlock Holmes.

Doyle died in 1930 and was buried in the town of Minstead in Hampshire, England. His tombstone lists his achievements as "Patriot, physician & a man of letters." There is no mention of Sherlock Holmes.

The fame of the peculiar fictional detective only grew stronger over time. His adventures with his sidekick, Dr. Watson, have been translated into 60 languages. The self-defined Holmesians and Sherlockians have formed clubs and secret societies all over the world, from Scotland to India to Australia and beyond. Legions of fans and scholars engage in what they call "the Grand Game," an ongoing analysis of the original 60 stories, which assumes Holmes and Watson were real people and Doyle was merely their literary agent.

Inspired fans have even established pilgrimage sites: There is a Sherlock Holmes monument in London outside the Baker Street tube station, near his fictional 221B Baker Street home address. There is another near Picardy Place, Doyle's birthplace, in Edinburgh, Scotland. Yet another statue, of pensive Sherlock sitting on a rock, can be found in what is now known as Sherlock Holmes Place in the sleepy Swiss town of Meiringen, the gateway to the stunning Reichenbach Falls, where Doyle sent Sherlock Holmes to die. In 2011, a bronze plaque dedicated to Professor Bell was installed in Edinburgh by Japanese fans of Sherlock Holmes at the professor's former resi-

dence, which is now the site of Japan's Consulate General in Scotland.

Hundreds of literary and film adaptations, radio series, comic books, musicals, video games—and one Japanese puppet-theater series—have been created featuring Sherlock Holmes and Dr. Watson. Even the Cold War couldn't stop the spread of Sherlock Holmes worship. In the 1980s, a critically acclaimed TV series about Holmes' adventures was produced and aired in the Soviet Union, where Sherlock Holmes novels remain among the most popular works of fiction of all time. Vasily Livanov, the Russian actor who portrayed Sherlock Holmes, became an Honorary Member of the Order of the British Empire in 2006, 20 years after the series stopped running. The role of Sherlock Holmes has also been played by other famous actors, including Roger Moore, Christopher Lee, Michael Caine, Ian McKellen, Peter O'Toole and Leonard Nimoy.

In 2009, British film director Guy Ritchie took his turn at telling the story in the action-packed blockbuster *Sherlock Holmes,* with Hollywood superstars Robert Downey Jr. and Jude Law as the famous detective and his loyal companion Dr. Watson. The film was so successful that it was followed in 2011 by *Sherlock Holmes: Game of Shadows.* The Franchise has generated over $1 billion at the box office worldwide and has created millions of new

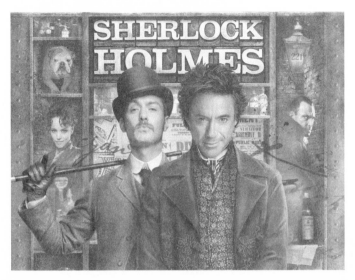

Sherlock Holmes, 2009

fans for the detective.

References to Sherlock Holmes have been made in *Star Trek*; and it was Sherlock Holmes and Dr. Watson who served as prototypes for the lead characters Dr. Gregory House and Dr. James Wilson in the popular American TV drama series *House*. Dr. House's flawless instincts and unconventional thinking, his acerbic personality, drug addiction and very name make him a worthy successor to Holmes.

Almost nine decades after Doyle's passing, many of his works have been forgotten by the general public—but not Sherlock Holmes. In 2010, a British-American TV series *Sherlock* was launched, starring Benedict Cumberbatch in the lead role. The series has been nominated for several Emmys, BAFTAs and Golden Globes, winning in several categories, as well as being awarded a Peabody Award in 2011. In 2012, the CBS network launched its own spin on the famous detective—*Elementary*, starring Jonny Lee Miller as Sherlock Holmes and Lucy Liu as Dr. Joan Watson, and set in modern-day New York City. The series has been praised for its writing, acting and its novel approach to the original material.

More than 130 years after his first public appearance, Sherlock Holmes remains very much "alive" and continues to inspire millions of fans worldwide—even though his own creator wanted him dead.

8

"If I had my life to live over, I wouldn't change it."

—*Renee Harris*

RENEE HARRIS

LIFE AFTER THE
TITANIC

Inspired by the memory of her beloved husband who perished on the *Titanic*, survivor Renee Harris went on to become the first female theatrical producer in America.

rene Wallach (who was known by her nickname "Renee") had everything going for her: Born in Washington, D.C., in 1876 to a prominent family, she was smart, good-looking and outgoing. At 22, Renee was enjoying her life, studying law and working evenings as a legal secretary in New York City, when she met Henry B. Harris at a music-hall

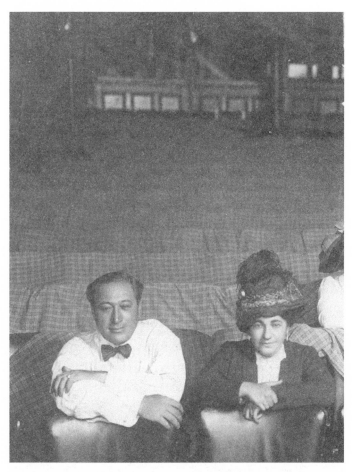

Henry and Renee Harris in a theater

matinee. When Renee felt the man seated behind her gently stroke the back of her neck during the performance, she turned around to rebuke him, but saw "the softest eyes and the loveliest smile" she'd ever seen. They had different personalities, but the two fell in love and got married. Although he was 10 years her senior, Renee called him "my boy."

Henry was a successful theatrical promoter, and he immediately recognized a similar talent in Renee. In 1901, the year after they got married, Henry set up their own company. He asked her to read plays that had been submitted to him and to offer her opinion on their potential. Her feedback was always smart and insightful, which helped him select the best material to produce. Such was her talent and vision that Henry once said to a friend, "I never take an important step without consulting Renee. If anything happens to me, she could pick up the reins." The two went on to produce plays together, never leaving each other's side. In 1903, Henry and a partner built the magnificent Hudson Theatre in New York, featuring the biggest lobby on Broadway and a spectacular Tiffany stained-glass dome in the ceiling. In two years, they were doing so well, they bought out their partner and acquired a second theater, named Harris in honor of Henry's father.

On April 10, 1912, the couple was heading back to

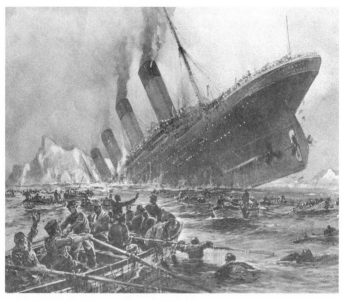

Sinking of the Titanic by Willy Stoewer, 1912

New York from England after a long European vacation. Hand in hand and in love, the two boarded a magnificent ship on its maiden voyage. It was the *Titanic*. On the night of April 14, they were playing cards in their room when Renee noticed that her clothes had stopped swinging on their hangers. The countdown to the end of their life together had begun.

Once the ship began to sink, lifeboats filled up quickly with women and children, but Renee refused to

leave her husband's side. When one of the last boats was about to leave, she felt herself being picked up and tossed down into the boat. "Catch my wife" were the last words she ever heard from Henry.

Renee made it safely to shore, but Henry went down with the ship; his body was never recovered.

Normally unflappably optimistic, Renee cried for two years—and then she never cried again. Surviving the *Titanic* tragedy inspired her to live life to the fullest. She recalled that Henry had always told her, "You are a much better businessman than I am," and vowed to honor his memory by continuing to be successful.

When Henry's estate was settled, she found that he had left many debts. Henry's father, a successful theater producer himself, advised her to call it quits. Renee refused to surrender and paid off every penny Henry owed, feeling that the best way to pay tribute to him and their life together was "to carry on his work and make the theater a monument to his memory." She took over the work they used to do together and became the first female theatrical producer in American history.

Her solo career started with a gutsy production. *Damaged Goods* was a play about syphilis, a taboo subject at that time. Unexpectedly, the play became a huge success and was praised for dispelling myths about the disease and enlightening the public on the subject. Renee

continued to bring her sense of social responsibility to her theater projects. During World War I, she arranged for a group of artists to perform in Paris for American troops, pioneering the concept of wartime entertainment. As her power as a producer grew, she gave many young actors and playwrights their start. Among them were Barbara Stanwyck (who later appeared in the 1953 movie *Titanic*), the great actress Dame Judith Anderson and writer/director Moss Hart.

Hart's own success story was built on the strength of Renee's vision: She was the only person who believed in his potential. Against all advice to the contrary, she produced his first play. *The Beloved Bandit* flopped everywhere, but she never lost either her faith in his talent or her famous sense of humor. In his memoirs, Hart recalled a comment from Renee after the play had received particularly scathing reviews in Rochester, New York. "Renee lit a cigarette and said, 'I'll tell you something, boy. The way it went tonight doesn't bother me a bit. You know why? First, this is Rochester—and what the hell does Rochester know about anything except Kodaks?'" Her encouragement made him stick with it. He went on to direct, among other things, such legendary musicals as *My Fair Lady* and *Camelot*. He also became a prolific playwright and screenwriter, and always gave credit for his stellar career to the encouragement he received from

Renee Harris in his early years.

At the height of her career, Renee was incredibly successful; she owned racehorses, a yacht, houses in New York, Maine and Florida, and turned down a million dollar offer for the Hudson Theatre that Henry and she had created together. She later lost the Hudson anyway when the Great Depression hit and the bank panicked and foreclosed on the building while she was in Europe. Renee walked away with the only object she could save from the landmark theater—a large portrait of Henry. Renee remarried three times, but Henry remained the love of her life. "I had four marriages but really only one husband," she said.

In 1967, 91-year-old Renee received a letter from 14-year-old Gregg Jasper from New Hampshire, who was fascinated with the history of the *Titanic*. When he saw Renee as a guest on a TV show, he wanted to know more. Renee answered his letter, and the two corresponded for six months—Renee answering his many questions about the voyage that ended in tragedy—until she finally invited his whole family to visit. The meeting changed the teenager's life: Not only was he meeting a real survivor of the *Titanic*, but he was also struck with how happy she turned out to be, in spite of being very frail. It was as if Henry B. Harris was still alive to Renee, and she enjoyed discussing him and their life together. A large portrait

of him dominated her living room. At one point, Renee got up and brought out cake and ice cream for everyone, leaving a long-lasting impression on Gregg. He learned that day from Renee to always be nice to others, to share however little you may have and to never give up. He kept his interest for everything related to the *Titanic*—including his newly found fascination with Renee Harris—from that day all through his adult life.

Renee lived to be 93, maintaining her vigor and happy disposition until the very end, often enjoying a martini in the afternoon with her old friends. She always said, "If I had my life to live over, I wouldn't change it."

9

"When I first read the script about three years ago, I started crying. I read it once more and cried again, so I knew it was something I should take seriously."

—Richard Gere
on "Hachi: A Dog's Tale"

HACHIKO

Japan's Most Loyal Dog

This story of a dog, who spent years loyally waiting for his master to return, inspired a nation and then the rest of the world, becoming a symbol of undying love and devotion.

n 2009, an American movie opened in Japan that everybody rushed to see. It wasn't because it featured a beloved star, Richard Gere. It was because the story was about Japan's own national hero, Hachiko the dog.

The movie, entitled *Hachi: A Dog's Tale,* was a love story unlike any other that Gere had ever starred in. It was inspired by real events

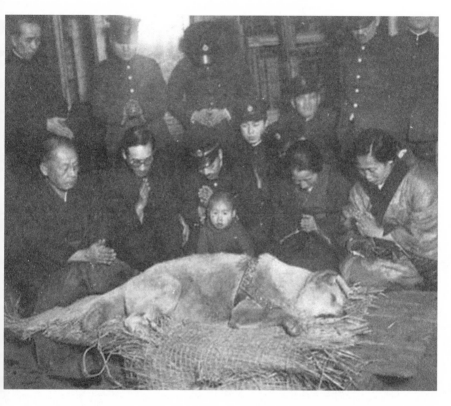

Hachiko—with his owner's wife Yaeko Ueno (front row, second from right) and station staff in mourning in Tokyo on March 8, 1935

that turned one man's dog into a Japanese national symbol of loyalty—the most respected character trait in Japanese culture, which still adheres to the ethical norms of the samurai code.

Hachiko was the real-life dog of Hidesaburo Ueno, a professor of agricultural science at Tokyo Imperial University. In 1923, Professor Ueno had the Akita pup sent to him from the town of Odate in the Akita prefecture. Ueno named him Hachi, which means "eight" in Japanese, a number that is considered lucky. The Akita breed is known for intelligence and loyalty, and Ueno and Hachiko's relationship was the perfect illustration of this: The dog quickly learned his way to the Shibuya station in Tokyo, where he went every day to meet Ueno when he returned home from work.

In 1925, Professor Ueno suffered a heart attack while giving a lecture and died on the spot. Even though his owner never arrived at the train station again, Hachiko never abandoned his call of duty. The two had only spent two years together as friends, but Hachiko continued going to the station to wait for his professor every day for nine years, nine months and 15 days.

People began to notice the dog's unusual behavior, and commuters started bringing him treats, food and water. At first annoyed at the presence of a stray dog, the train station management eventually grew fond of

his constant presence. After an unsuccessful attempt at giving Hachiko to a new owner—he kept escaping—the dog was adopted by Kikuzaburo Kobayashi, Ueno's former gardener, whose house was in Tomigaya within walking distance of Shibuya. The story of Hachiko grew bigger and bigger, until a 1932 newspaper article turned Hachiko into a national sensation as a symbol of familial loyalty. In 1934, the city erected a bronze statue in his honor at the Shibuya station, with Hachiko himself present at the unveiling, surrounded by crowds of fans. Hachiko was no longer a lone dog who belonged to no one.

Hachiko passed away at the station in 1935. The professor's widow was called in to pay her respects. Together with several station workers, she was photographed kneeling next to Hachiko's body, bowing in reverence to the dog who had become a national symbol of unwavering loyalty. Hachiko's remains were cremated and buried in Aoyama Cemetery in Tokyo beside his master. His hide was stuffed and mounted as a permanent display at the National Science Museum of Japan in Tokyo. During World War II, Hachiko's statue at Shibuya Station was recycled for the war effort, but it was erected again, with a dedication ceremony, in 1948. Bronze paw prints were installed at Hachiko's exact waiting spot on the station's pavement. Another statue and Hachiko-themed manholes decorate the streets of Hachiko's immensely proud

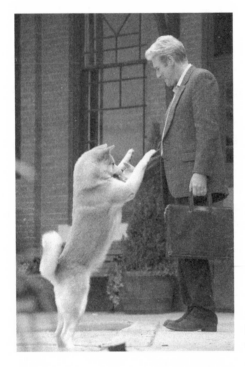

Richard Gere in *Hachi:
A Dog's Tale*, 2009

birth town of Odate in the Akita prefecture.

The loyal dog has never left the public consciouness. In 1987, a Japanese movie called *Hachiko Monogotari* about the hero Akita and Professor Ueno became a top-grossing movie of the year in Japan. In 1994, scientists reconstructed an old record, and millions of Japanese listeners tuned in to the radio to hear Hachiko bark—59

years after his death. In 2012, rare photographs from the dog's life were exhibited, and Hachiko's fans, many of them fourth generation, waited in line for hours to see the exhibition.

When Sony Pictures decided to produce an American version of the story, Richard Gere immediately joined the project. In an interview, he said that reading the script left him in tears, and he felt honored to help bring the story to a worldwide audience. Gere said about the incredible relationship between the professor and Hachiko: "There is no subservience, no master and no dog; rather, they are soul friends." *Hachi: A Dog's Tale* was set in a small town in New England, with Gere playing an American professor who has been given an Akita pup. In Japan, Sony released the movie on April 8, the day on which Hachiko is celebrated each year with a remembrance ceremony at Shibuya station.

Thanks to the star appeal of Richard Gere, *Hachi: A Dog's Tale* made over $45 million dollars at the global box office and created legions of new fans for Hachiko the dog and the Akita breed. In America, Hachiko became a household name among dog lovers. In 2012, the town of Woonsocket, Rhode Island, where *Hachi: A Dog's Tale* was filmed, unveiled a permanent bronze statue of Hachiko, an exact replica of the Shibuya statue, in Woonsocket Depot Square. The mayor of Woonsocket and the

consul general of Japan were in attendance. Two cherry blossom trees—symbols of the fragility and beauty of life—were planted beside the statue, to remind visitors that life is tragically short but also incredibly beautiful.

The story continues to inspire the public: References to Hachiko pepper popular shows, from *Futurama* to *Scooby-Doo,* and various video games.

In 2015, 90 years after Professor Ueno's death and 80 years after Hachiko's death, the two were finally reunited. Thanks to a wide public campaign, the University of Tokyo unveiled a bronze monument of Professor Ueno and Hachiko, paws in hands, as a permanent reminder of their inspirational friendship for generations to come.

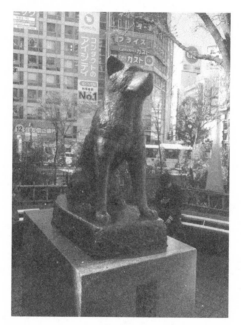

Hachiko statue at Shibuya Station, Tokyo

10

"Some day they'll go down together
they'll bury them side by side.
To few it'll be grief,
to the law a relief
but it's death for Bonnie and Clyde."

—*Bonnie Parker*
The Trail's End

BONNIE AND CLYDE

GONE BUT NOT FORGOTTEN

Inspired by Hollywood glamour, Bonnie Parker posed for a staged photo that turned her and Clyde Barrow from small-town criminal lovers on the run into an enduring American legend.

B onnie Parker was born in 1910—the same year the first movie was produced in Hollywood, California.

After Bonnie's father died, her widowed mother struggled to support her three children by working as a seamstress. Life was painfully slow and tragically predictable in tiny Cement City, Texas, known locally as "The Devil's Back

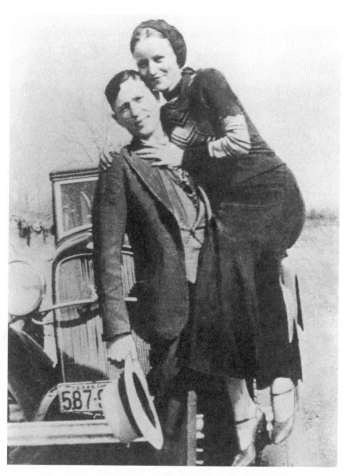

Bonnie and Clyde, ca. 1933

Porch." But Bonnie Parker stood out among other kids: Petite and beautiful, she was an honors student, wrote poetry, performed Broadway hits on the school stage and dreamed of Hollywood. Everyone around her just knew that Bonnie was destined for something bigger.

Averse to the boredom of the mundane life surrounding her, Bonnie dropped out of high school and married her first love, Roy Thornton, before she turned 16. She was deeply in love and had their names tattooed on her inner right thigh. But Roy was trouble. He ran with the wrong crowd and less than a year into their marriage, he was sentenced to five years in prison for robbery. Bonnie's dreams of a better life were shattered.

Forced back into a monotonous ordinary existence, Bonnie got a job as a waitress in a diner. Three years later, Clyde Barrow walked into her life while she was making hot chocolate in a friend's kitchen. The smart and beautiful girl with a passionate heart was about to get her wish: She would find true love, lead a very exciting life, and become a huge celebrity—although not quite how she imagined it.

Her tall, dark and handsome 22-year-old Prince Charming was already a criminal. Growing up in a dirt-poor family, Clyde longed to become a musician, playing the guitar and saxophone, but his older brother Buck led him astray. Clyde was first arrested at 17, when he and

Buck were caught with a truckload of stolen turkeys. His crime escalated from there—from cracking safes to stealing cars to robbing gas stations.

Just two weeks after Bonnie and Clyde fell in love, Clyde was arrested again and thrown behind bars. Lovesick, Bonnie was not going to return to a boring life in a small town and let another love of hers rot in jail. She managed to sneak a gun to Clyde, and he escaped with his cell mates, but was caught and sentenced to 14 years of hard labor. Bonnie's dream seemed doomed once again. Two years later, Clyde cut off his big toe and part of another in an act of desperation to avoid hard labor, before learning that somehow his mother had already managed to convince a judge to let him out on parole.

When Clyde was released, the lovers promised to never leave each other's side again. Clyde formed a gang that went on to rob local gas stations and rural stores. The loot was small, so they moved up to robbing local banks. Bonnie never went inside a bank or fired a weapon. Sometimes, she waited in the getaway car; other times, she wasn't even at the scene, but in a safe place.

Through it all, the two held on to their childhood dreams: Clyde always kept his guitar with him, while Bonnie still loved her Hollywood magazines that police often found in the stolen cars abandoned by the gang. She also kept writing poems, all about their dangerous

path, destined to end badly. Once, somebody brought a camera to the place where the gang was hiding. A dedicated student of everything Hollywood, Bonnie staged a photo shoot: Clad in a tight skirt and a beret, cigar in her mouth, she posed clutching a machine gun, leaning on a car door, smiling straight into camera—beautiful, fearless, a star.

Her art direction proved very successful. When the press got hold of the photos from a roll of film found by the police in an abandoned house where the gang had been hiding out in Joplin, Missouri, Bonnie and Clyde became an overnight sensation. Although Bonnie never actually smoked cigars or fired a gun, the staged photo gave birth to her image as a femme fatale, "gun moll" becoming her official moniker in the media. The story of two young lovers on the run catapulted Bonnie and Clyde into instant, Hollywood-level celebrity.

At first, the public rooted for Bonnie and Clyde. They were rule-breaking, gutsy heroes in the eyes of many suffering from the Great Depression. But public opinion quickly turned sour when the gang shot a rookie cop whose bride wore a wedding dress to his funeral. Now everybody wanted them dead with equal passion. The hunt for Bonnie and Clyde became America's favorite story.

When Bonnie and Clyde were finally ambushed by the police on May 23, 1934, on a rural road in Louisi-

ana, police fired 167 rounds into the stolen Ford V8, killing Clyde first, and the hysterically screaming Bonnie next. When the smoke cleared, the car looked like a piece of Swiss cheese. Bonnie was 23 years old. Clyde was 25.

When the news broke, it was the biggest sensation in the country. In death, Bonnie and Clyde created more morbid fans than when they were alive. Locals swarmed in to collect souvenirs. Women tried to snatch locks of Bonnie's hair and pieces of her dress drenched in blood and tissue; one even attempted to steal one of her fingers that had been shot off. A local man tried to cut off Clyde's ear before the police intervened; someone else tried to steal his "trigger" finger. A cop made off with Clyde's saxophone, covered in both lovers' blood.

Over 10,000 thrill-seekers flocked into nearby Arcadia, Louisiana, where the bodies were transported, swelling the tiny town sixfold. The crowds were so out of control, the undertaker resorted to squirting embalming fluid to keep the gawkers away from the bodies.

Bonnie's family took her home to Dallas, where her funeral became the biggest show of the year with 20,000 spectators. The funeral home was drowned in flowers, the biggest floral arrangement delivered from a group of Dallas newsboys. The sudden death of Bonnie and Clyde sold an unprecedented half a million newspapers in Dal-

las alone. Bonnie was now a bigger celebrity than she had ever dreamed of becoming.

Bonnie's dreams of Hollywood came true 30 years later when the 1967 movie *Bonnie and Clyde*, starring Faye Dunaway and Warren Beatty, became a nationwide hit. The film established a new standard for violence on the silver screen: In the final scene, when Bonnie and Clyde are showered with bullets in their car, the camera focuses closely on blood splattering and bodies jerking from the gunshots in a way never shown before. The movie was equally praised and condemned for its perceived glorification of violence, but the public was united in their renewed adoration for the story of the doomed gangster lovers on the run. *Bonnie and Clyde* was nominated for 10 Academy Awards, including Best Picture, Best Actress and Best Actor, and seven Golden Globe Awards. Both Dunaway and Beatty—who insisted on also producing the film—became media darlings, much like Bonnie and Clyde just a few decades before.

The film also inspired a fledging 25-year-old film critic to write a memorable review in which he called it—contrary to many established critics—the "landmark" work of the American cinema, "pitilessly cruel, filled with sympathy, nauseating, funny, heartbreaking and astonishingly beautiful." That critic was Roger Ebert, and that review launched his own illustrious career.

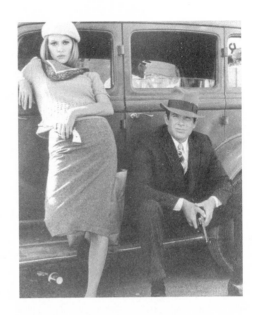

Faye Dunaway and
Warren Beatty in
Bonnie and Clyde,
1967

In a twist that Bonnie would have undoubtedly appreciated, the film helped popularize the image of Bonnie and Clyde as glamorous characters: Not only were Dunaway and Beatty much better looking than the real Bonnie and Clyde, the characters were also impeccably styled. Bonnie's sleek on-screen outfits started a revolution in women's fashion. The iconic beret worn askew by Dunaway as Bonnie became the hottest sought-after fashion item, causing beret production in France to double almost overnight.

Over 80 years after their deaths, Bonnie and Clyde continue to live in the public imagination. Their story appears in every layer of popular culture, from being one of the most popular Halloween costumes for couples to wear to inspiring countless documentaries, musicals, TV miniseries and songs—ranging from the melancholic 1968 single *Bonnie and Clyde* by French superstars Serge Gainsbourg and Brigitte Bardot, covered in 2011 by Lulu Gainsbourg and Scarlett Johansson, to the unexpected, but appropriately glamorous *03 Bonnie and Clyde* music video by Jay-Z and Beyoncé, who also titled their 2015 tour *On the Run* thus paying homage to the original celebrity gangster couple.

As Clyde's tombstone prophetically reads, Bonnie and Clyde are "Gone, but not forgotten."

11

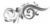

*"Why should I complain about making $700
a week playing a maid? If I didn't, I'd be
making $7 a week being one."*

—Hattie McDaniel

HATTIE MCDANIEL

THE MAID AND HER OSCAR

Inspired to break away from a lifetime of working as a maid, Hattie McDaniel made history by winning an unprecedented Oscar for playing one on the silver screen in the most successful Hollywood movie of all time.

n 1937, Atlanta native Margaret Mitchell won the Pulitzer Prize for her novel *Gone With the Wind*, the tragic love story set in the American South during the Civil War. In spite of being published during the Great Depression, the novel sold a million copies in its first six months, breaking all records. It has been

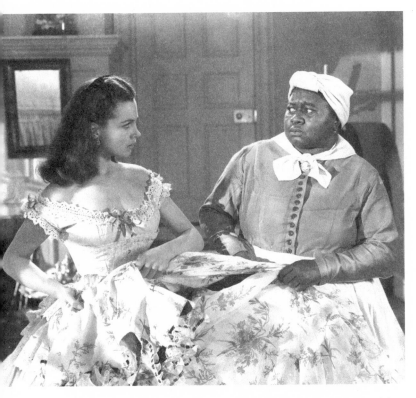

Gone With the Wind, Vivien Leigh and Hattie McDaniel, 1939

translated into more than 40 languages and remains one of the most widely read books of all time.

The 1939 movie adaptation was a hit as well: Setting a record at the 12th annual Academy Awards ceremony, the film won in eight of 13 categories, including Best Picture, a record held for almost 20 years. There was something else remarkable about that night: Hattie McDaniel, who played the unforgettable slave/maid, Mammy, became the first African-American actor and woman to be nominated and win an Oscar for a supporting role in a motion picture.

It had been a long and arduous road for Hattie McDaniel to share the screen, and the accolades, with the likes of Hollywood stars Clark Gable and Vivien Leigh. She had to beat a lot of other contenders for the role in the movie. The book had been so popular, even Eleanor Roosevelt lobbied for her maid to play the part. But it was McDaniel—who had been playing a lot of maids and working as one in between movie gigs—who got the role.

McDaniel was born the youngest of 13 children to two former slaves in Wichita, Kansas, in 1895. A gifted singer, comedienne and songwriter, she started performing onstage when she was just 13, working in her brother's minstrel show and then touring with the black ensemble Melody Hounds. In the mid-1920s, she became the first black woman to sing on the radio in the United States.

When the stock market crashed in 1929, opportunities were scarce. McDaniel became a washroom attendant and a waitress in a Milwaukee club until she managed to find her way onstage there. In 1931, she moved to Los Angeles, where her brother Sam got her a spot on the radio. Her performance as the character "Hi-Hat Hattie," a bossy maid with attitude, earned her increasing popularity but low pay, so she continued to work as a maid to support herself.

As a large, dark-skinned woman, McDaniel was typecast from the start. Her first movie role was as a maid in 1932 in *The Golden West*. Her second was as a maid in *I'm No Angel* with Mae West. McDaniel was criticized by African-American civil rights organizations for perpetuating the stereotype, to which she replied: "Why should I complain about making $700 a week playing a maid? If I didn't, I'd be making $7 a week being one." When she wasn't playing a maid, she sang in chorus lines. McDaniel acted in more than 300 movies and is credited for 80 of them.

Thanks to her hard work and high spirits, she made many friends in the industry, including Joan Crawford, Ronald Reagan, Bette Davis and Clark Gable, whose support may have helped her get the part in *Gone With the Wind*.

Winning the Oscar didn't make McDaniel's life any easier, though. In Atlanta, the movie's stylish opening

ceremony was planned with the entire cast taking part, but the local decision makers intervened. Atlanta still had segregation laws, and the African-American actors weren't allowed to attend the premiere in a segregated movie theater. They were also excluded from all print advertising, in spite of producer David O. Selznick's attempt to secure an exception for McDaniel. Clark Gable threatened to boycott the premiere, but McDaniel convinced him to go. At the Oscar ceremony itself, McDaniel and her escort were seated away from the white stars of the movie, at a table in the back. When her name was announced, she had to walk all the way across the room to accept the award, an awkward moment that was edited out of the telecast. Clark Gable shook her hand, Vivien Leigh kissed her and McDaniel went onstage, head held high, in a royal blue dress, white gardenias in her hair. In a shaky but dignified voice, she thanked the Academy for the honor and said she sincerely hoped to remain "a credit to her race and to the motion picture industry."

The role of Mammy made McDaniel, already criticized for her maid roles, a primary target for the NAACP's leader Walter White, who accused the movie of glorifying slavery and blamed McDaniel for holding back the fight for civil rights. As the first black woman to ever perform on the radio and the first black Oscar winner, McDaniel was proud of her achievements, arguing that Walter

Hattie McDaniel accepting her Best
Supporting Actress Oscar from Fay
Bainter, Feb. 29, 1940

White could not possibly speak on behalf of every black
person as a light-skinned, one-eighth black person him-
self. The rest of the black community was divided. Some
praised McDaniel's historic Oscar win. Others, including
Malcolm X in his later memoirs, sided with the NAACP
in calling the movie "a weapon of terror against black
America."

McDaniel went on to play in several more films, a
maid in many of them. Later in life, she became the first
black American to star in her own radio show, *Beulah*.
She continued to face criticism for her roles, her use of a

white agent and her absence from the civil rights movement.

Hattie McDaniel died of breast cancer at the age of 57. Her funeral was attended by thousands. Her dying wish to be buried in Hollywood Cemetery was denied —it was for whites only. In 1999, the new owner of the cemetery offered to have her remains relocated, but when her family refused to disturb them, he installed a plaque in the cemetery in her honor.

McDaniel's talent, perseverance against the odds and achievements in the radio and movie industries continue to inspire actors, performers and the general public. In 1975, she was inducted into the Black Filmmakers Hall of Fame. The 1994 *Hi-Hat Hattie!*, a one-woman show about McDaniel written by Larry Parr, toured the country starring Karla Burns, an American actress and operatic mezzo-soprano, herself a Wichita native and the first black woman to win Britain's coveted Laurence Olivier Award for theater. The 2002 AMC special *Beyond Tara: The Extraordinary Life of Hattie McDaniel* won a Daytime Emmy Award. The special was hosted by Whoopi Goldberg, who was the next black woman to win an Oscar for her supporting role in 1990's *Ghost*, 51 years after Hattie's win. In 2006, an image of McDaniel on Oscar night was featured on a U.S. postal stamp. In 2007, actress Vickilyn Reynolds launched the musical

Hattie… What I Need You to Know, which was praised by McDaniel's great-grandnephew Kevin John Goff, who is producing a three-part documentary on McDaniel's life. A star with her name is included on the Hollywood Walk of Fame.

In 2015, 76 years after its premiere, *Gone With the Wind* still held the record as the highest-grossing film of all time (adjusted for inflation), way ahead of even *The Sound of Music*, *Titanic* and *Avatar*.

By the end of 2015, a total of 66 black actors and actresses have been nominated for an Oscar and 15 have won the award for a leading or supporting role in a motion picture.

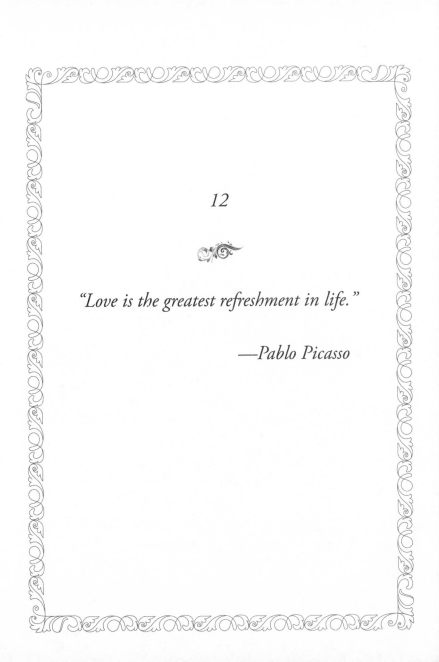

12

"*Love is the greatest refreshment in life.*"

—Pablo Picasso

PABLO PICASSO

Tragic Muses

Inspired by the female character and form, Pablo Picasso created some of the most memorable and valuable pieces in modern art—while most of his muses paid for his admiration with their lives.

P ablo Picasso is one of the most prolific and famous artists of the 20th century. He lived to be 91, produced thousands of works of art, created new art movements, became a household name and remains one of the highest-selling artists to date.

They say behind every great man there is a great woman. Picasso was as prolific in his love

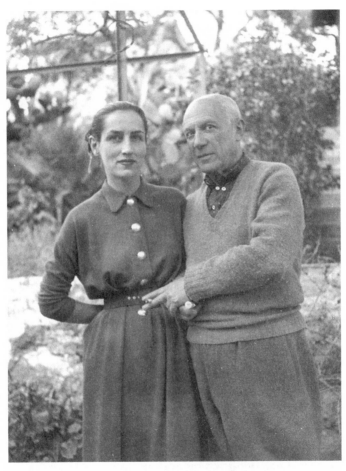

Pablo Picasso and his muse
Françoise Gilot, 1951

life as he was as an artist: His incredibly varied and strik-
ing art was inspired by numerous affairs with women.
Many he abandoned, some he married, a few left him,
but each paid a steep price for being his muse.

When young Picasso moved from his native Spain
to Paris in 1904 and met Fernande Olivier, she was the
"It" girl of the art world. Strikingly beautiful with soft
features and wavy hair, she modeled for many established
artists—but she fell for the young and passionate Pablo.
Beneath her beautiful appearance, Olivier hid her dark
past: She was an illegitimate child raised by an aunt; she
escaped an arranged marriage to an abusive man, then
changed her name and moved to Paris to create a new
life for herself. It seemed like her luck took a turn for
the better when she became Picasso's muse. He was en-
thralled by her beauty, creating over 60 portraits of her.
But the seven-year affair ended badly. In an attempt to
create a family of her own with Picasso, Olivier adopted a
13-year-old girl. One day, Olivier discovered nude draw-
ings of the orphan sketched by Picasso. The girl was sent
back to the orphanage. The two separated. Twenty years
later, Olivier, who was left without any means of sup-
port, tried to publish a memoir of her time with Picasso.
Picasso paid her to remain silent for as long as he was still
alive. She managed to get a few installments published in
1930 in a Belgian daily, but the money didn't last long.

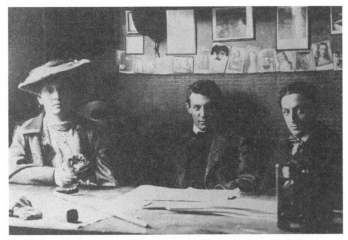

Fernande Olivier, Picasso and Ramón Reventós in Barcelona in 1906

Deaf and suffering from arthritis, Olivier died before Picasso at the age of 85 in 1966.

Picasso seemed to be always in search of a muse to fall in love with—until he would inevitably move on to the next one. Months before his affair with Olivier ended in 1912, Picasso had already fallen in love with Marcelle Humbert, known as Eva Gouel. His passion for her was so strong he signed some paintings from their time together with "I love Eva." Always frail and thin, Humbert died at 30 from tuberculosis. Picasso was devastated. Except, while Humbert languished on her deathbed, he began an affair with a ravishing 27-year-old Parisian, Gaby Lespinasse, who lived in the same building where his studio

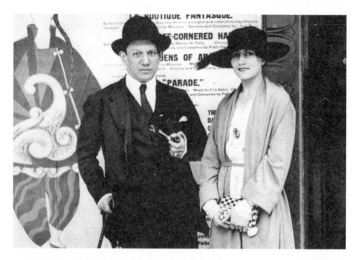

Picasso and Olga Khokhlova, 1919

was located. Gaby walked away unscathed shortly after and married an American, without inspiring any major work by Picasso.

In 1917, Picasso met a beautiful, green-eyed and melancholic Russian ballerina. Olga Khokhlova was 28 years old to his 37 and from a noble family. She wouldn't give in to him without a commitment, so he married her. Olga gave birth to Picasso's first son, Paulo, inspiring him to explore the mother-and-child theme. Picasso painted dozens of portraits of Olga. However, she was also jealous, possessive and had rigid views on how the family

should live. She insisted on running a perfectly organized household with an impeccable staff. She did not approve of drinking or Picasso's bohemian friends with their loose morals. She insisted Picasso live up to his status by hiring a chauffeur to drive him around. And she was an over-protective mother. The two remained together for two conflict-ridden decades until Khokhlova discovered that Picasso had been having a 10-year affair with a French art model, which started when the girl was 17 and lived across from them—and that the mistress was now pregnant. Deeply insulted, Madame Picasso demanded a divorce, with property evenly divided. When Picasso refused to meet her demands, Olga fled to southern France with their son. The two were still officially married when she died of cancer 20 years later at the age of 64.

Picasso did not attend the funeral. His relationship with his son Paulo was always strained. When Paulo, who never became successful, would come to Picasso to beg for money with his two young children, Pablito and Marina, they were often kept waiting at the gate for hours in the midday heat. Picasso despised Paulo for not living up to his great name. Picasso's grandson Pablito craved a relationship with his grandfather, but Picasso never gave him much time. Nor did Picasso pay much attention to Marina, who remembered Picasso's pet goat Esmeralda having more fun at Picasso's villa in Cannes than the two

grandchildren were allowed to have. In her memoir, Marina later wrote that sometimes Picasso would eat in front of the hungry grandchildren, and that the memory of him once giving her a walnut-stuffed fig was one of the warmest gestures he ever extended to her.

The young woman who prompted Picasso's divorce from Olga was Marie-Thérèse Walter. Picasso was 45 when he began the affair with the teenager in 1927. Walter gave birth to his daughter, Maya, and inspired his famous painting *Le Rêve (The Dream)*. Picasso painted Marie-Thérèse as airy and happy, awash in sunlight, hugging her round stomach—a blissful moment in the life of a young mother. He painted his daughter, too—his famous *Maya With Doll* is a vivid example of the Cubism style he pioneered. The relationship with Marie-Thérèse ended in a predictable pattern just eight years later when Picasso fell in love with a new muse, Dora Maar in 1936.

At first, Dora Maar seemed a worthy match for Picasso. Born of French and Croatian parents and raised in Argentina, Maar was an artist, a photographer and a painter herself. Smart, creative and passionate, she dove into her role as muse headfirst. When Picasso started working on *Guernica* to express his dismay over the horrors of war, she helped him paint several elements of the masterpiece and replaced his regular photographer in documenting the process of creating it. Picasso even

Marie-Thérèse Walter, 1928

painted Maar's features onto a figure of a woman hold-
ing a lamp. It was fitting he used her face in one of the
most mournful paintings of his career: Picasso seemed
to be inspired by the misery he saw in her. He painted a
Cubist portrait of her titled *Weeping Woman*, explaining
that all women were "suffering machines" and that Maar
"was always a weeping woman for him," a vision that was
"forced on him as deep reality."

It didn't help that Maar was sterile, and that Picasso
constantly compared her to Walter, who was still around

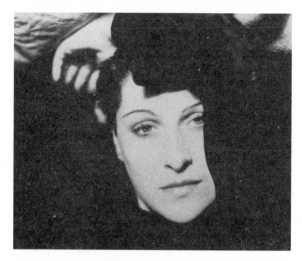

Portrait of Dora Maar by
Man Ray, 1936

for many years, pitting Walter's soft demeanor and fertile femininity against Maar's strong character and inner turmoil. When Walter stormed into his studio one day with Maar there, Picasso suggested that the two women literally fight over him. This resulted in a wrestling match between the 26-year-old Walter and 28-year-old Maar, which the then 54-year-old artist would later refer to as one of his "choicest memories."

When Picasso inevitably replaced her after eight years with a younger artist, Maar became so distraught

she was taken to a mental institution, where she under-
went three weeks of electric-shock treatments, followed
by years of therapy. That didn't stop Picasso from tor-
menting her long after their physical relationship had
ended. He bragged to her about his new mistress, shared
with the world his sketches of Maar's crotch (which she
tried to keep private) and sent her mocking gifts—in-
cluding a chair made of steel rods and coarse rope. De-
spite Picasso's cruelty, no one in Maar's life ever replaced
him. "After Picasso, only God," she once said. She kept
living on her memories of him and on proceeds from
selling those of his paintings she had acquired during
their relationship, painfully aware the artwork in her pos-
session was more valuable simply because she had been
made a public spectacle for so many years. Dora Maar
died a recluse at age 89.

Maar's replacement was Françoise Gilot, a French
woman who was 21 to Picasso's 61. Passionate about art,
she had dropped out of law school to pursue the life of
an artist. Picasso was in awe of her beauty the minute he
saw her in a cafe in Paris—and brought over a bowl of
cherries as a sign of his affection. Gilot had two children
with Picasso, Claude and Paloma. Predictably, their affair
lasted just nine years, from 1944 to 1953. Gilot wrote a
book entitled *Life With Picasso*, which led to a legal battle.
At one point, she claimed Picasso was mentally unstable.

As with his first lover's memoirs, he fought to keep the book off the shelves, but she ultimately won the right to publish it. The book sold a million copies in its first year. Picasso was so infuriated that he disinherited Claude and Paloma and only saw them a few times before his death.

Picasso's second wife and his final muse was Jacqueline Roque. When they met in 1961 at a party, she was 26 and he 72. Picasso passionately pursued Roque for months. He painted a dove on the side of her house and sent her a rose every day for six months until she agreed to date him. Roque knew of his reputation. Upon finally giving in to the relationship, she told him, "If one day there is another muse, I'll congratulate her, I'll send her flowers. But I'll be out the door." The two married in secret and were together for the rest of his life. Picasso produced more than 400 portraits of Roque, more than any of his other muses. Roque contributed to this grand output by working tirelessly for her artist husband. She became his guard, keeping away the hordes of art dealers, curious celebrities, students and tourists. She also treated him like God, calling him Monsignor and often kissing his hand in reverence. A close friend described Roque as having "made up her mind fairly early on to sacrifice herself on the altar of his art."

Picasso passed away in 1973 at the age of 91. On the night of his burial, Roque slept on the snow covering

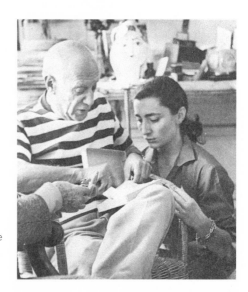

Picasso and
Jacqueline Roque
in their house in
Vallauris, 1961

his grave. She also shut the gates of their mansion, preventing Françoise's children, Claude and Paloma, from attending his funeral. His grandson Pablito, who suffered from the family's trauma, committed suicide by drinking from a bottle of bleach. It took him several painful months to die. Two years later, Picasso's son Paulo died from alcoholism. Four years after Picasso's death, 68-year-old Marie-Thérèse Walter—who had spent the rest of her life clinging to her memories of her first love with Picasso—hanged herself in her garage. His last muse, Roque, shot herself in the head in 1986 at the age of 59.

Picasso left behind over 45,000 paintings, ceramics, lithographs and sketches. His granddaughter Marina, who inherited one-fifth of the enormous art collection left without a will, sold off many of the paintings she received, to be rid of the terrible memories of her childhood. She kept his mansion in Cannes and, in it, a painting of her grandmother Olga on the wall. In her memoirs *Picasso: My Grandfather,* she wrote, "His brilliant oeuvre demanded human sacrifices. He needed the blood of those who loved him—people who thought they loved a human being, whereas they really loved Picasso."

Gilot is still alive and in her nineties. An artist in her own right, Gilot continues to paint and refuses to let Picasso's name dominate any discussion, keeping the focus on her own life and works. Aware that her portraits by Picasso are not as widely praised by the public as his portraits of other women, she explains it's because she never fell under the spell of his vision of her, always remaining her own person.

Picasso remains one of the giants of modern art, whose paintings break records at auctions worldwide. He has become the symbol of limitless creativity and the standard for artistic longevity. He also left behind a legacy of passionate love affairs, heartbreak and tragedy—the price his muses paid for inspiring his art.

Pablo Picasso, *The Weeping Woman*, 1937

13

"I have Dalinian thought: the one thing the world will never have enough of is the outrageous."

—*Salvador Dalí*

GALA AND SALVADOR DALÍ

SURREAL LOVE

Inspired by the fame that his art would bring, Gala became part wife, part mother, part manager and inspiration for the most famous artist of the Surrealist movement.

The history of art is full of stories of selfless women who chose to live in the shadow of a famous man, inspiring his genius at the expense of their own desires and ambitions.

This is not one of those stories.

From the moment 25-year-old Salvador Dalí, a rising Surrealist star from Spain,

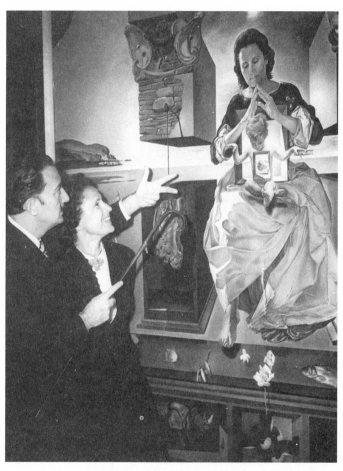

Salvador Dalí and his wife, Gala,
looking at one of his paintings,
entitled *The Madonna of Port Lligat*,
1951

laid eyes on Gala, a 35-year-old Russian woman, on the shores of the French Riviera in the summer of 1929, the two would break all the rules of engagement between an artist and his muse.

First, Gala was not a young ingénue—she was 10 years older than Dalí. She was also married.

When Dalí met Gala and her French husband, Paul Éluard, the couple had been together for 14 years, having met as teenagers in a health clinic in Switzerland. Her real name was Elena Ivanovna Diakonova, and it was Éluard who nicknamed her Gala. Gala and her husband had survived many challenges throughout their relationship. She had to win over his mother, which she did by sending her long thoughtful letters. Then she managed a treacherous solo journey from Moscow through Helsinki, Stockholm and London to Paris to reunite with Paul, an adventure not every man, let alone woman, would dare to attempt at the turn of the 20th century in volatile Europe. The two finally got married, but then Paul joined the French army at the front lines of World War I. When he returned, he made a new friend—an enigmatic and talented German artist, sculptor and poet, Max Ernst. Paul and Max were like-minded artists. Gala openly took Max as her lover. Ernst moved in with her, Paul and their baby Cécile—and for years they lived as a ménage à trois. Their home life was far from ordinary; Ernst drew on the

walls of the house, often with little Cécile sleeping in the same room—aardvarks, ducks on wheels, naked ballerinas on a boat. Then, Paul became depressed and disappeared for months, and Gala traveled across the world to retrieve him in Saigon.

It was an eventful marriage that would have kept any other woman occupied, but Gala grew bored. When Gala met young Salvador Dalí, she instantly shed her old life like a snake sheds its skin. Recognizing a mad genius in the young Spaniard, Gala abandoned Cécile, Paul and all her lovers to become Dalí's muse, manager, wife and mother in one.

Gala and Dalí were a very strange pair, even for the bohemian circles of Europe. With her small dark eyes, pointy nose and wavy dark hair, Gala looked like a bird of prey——and nothing like Russian ballerinas famous for their Slavic beauty. Dalí was petite to the point of being almost effeminate. Gala had, as Éluard put it, "a gaze that could pierce walls." She was an unabashed nymphomaniac. Dalí had a phobia of female genitalia, and his only other passionate relationship, a suppressed and unconsummated one had been with a fellow Spaniard, poet Federico García Lorca.

To everybody's surprise, Dalí and Gala became instantly inseparable. The odd couple took their first trip together to Torremolinos, a sleepy fishing town in the

south of Spain, where they terrorized conservative Catholic locals by sunbathing nude and staging public displays of affection. Two months later, Dalí asked Gala what she wanted from him, to which Gala replied, "I want you to kill me." In his memoirs, Dalí claimed this very moment cured him of his madness, as the fits of laughter and hysteria he had experienced since childhood suddenly stopped. Dalí announced his love for Gala to his family. His father, a devout Catholic and a conservative lawyer, vehemently opposed his son's relationship with the scandalous married Russian woman. In a gesture worthy of a Greek tragedy, Dalí shaved his head, buried his hair on the beach outside his childhood home in Figueres—the one whose landscape inspired much of his art—and followed Gala to Paris.

If it was love, it wasn't in the usual sense of the word. In his autobiography, Dalí said: "She wanted something, something which would be the fulfillment of her own myth. And this thing that she wanted was something that she was beginning to think perhaps only I could give her." Gala's intuition was right. He was strange, but his allure was undeniable. Among the many artists and poets of the time who rose to fame because of their work, Dalí quickly became a public sensation—as much for his persona as for his art. The signature moustache, the vaudeville-style outfits, giving a lecture in a deep-sea diving suit with two

The treatment is beginning to work, apparently, for Señor Dalí has now begun to sketch while the perfumed pads continue the compression of his eyeballs.

Russian wolfhounds on a leash, the memoirs in which he documented and analyzed his own bowel movements— Gala was by his side through all of it. Dalí had himself photographed lying down on a couch, eyes closed, with

Gala patting his eyelids with cotton swabs soaked in perfume, which he claimed helped him generate visions that made his art unmistakably "Dalinian"—melting clocks, burning giraffes, elephants walking on spider legs, disassembled human bodies traveling through space. Dalí refused to lead a normal life, and Gala was the method to his madness.

The pair never had children. Gala avoided her daughter with Éluard and dedicated all of her time to Dalí's career. She handled his money, negotiated with buyers, scheduled his days to be sure he painted, researched and purchased the best paints available, and selected the frames for his work. She managed his every interaction with the outside world, enforcing rigid rules. Her demeanor was stern, her willpower overwhelming. Some compared her to a dragon, others to the plague. She made him very productive—and very successful. Money flowed in. Dalí became such a commercially driven spectacle even the Surrealists disowned him. The movement's leader, André Breton, published an anagram turning "Salvador Dalí" into "Avida Dollars" mocking Dalí's hunger for money.

Whether Dalí was motivated by Gala or was being used by her to satisfy her own hunger for fame, everybody agreed the two were perfect for each other. Dalí dedicated many paintings to Gala, with her often nude

and always the center of a composition. His 1949 painting *Madonna of Port Lligat* portrayed her, ironically, as the Virgin Mary, was blessed by Pope Pius XII and inspired harsh criticism from his antireligious friends. Gala was depicted both as a divine power and as a woman of flesh, full of the kind of desire almost never seen in portraits of middle-aged women. Later in life, Dalí started signing his paintings with "(i)t is mostly with your blood, Gala, that I paint my pictures."

All along, Gala never stopped finding increasingly younger lovers. In her late 60s, Gala became infatuated with 22-year-old William Rotlein, an aspiring actor with a drug problem whom she met in New York. He reminded her of young Dalí himself, so she cleaned him up and had him profess eternal love to her on the tomb of Romeo and Juliet. The affair lasted four years and worried Dalí. Ever a mother and a muse, Gala wanted Rotlein to play young Dalí in a movie by Fellini, so she took him to Rome for a screen test with the famous director. When Rotlein failed to get a part in the movie, Gala immediately lost interest in him and moved on. Rotlein died of a drug overdose shortly after.

Meanwhile, Dalí had his own ever-changing circle of muses. After his student and muse Ultra Violet, a French-American artist, left him for Andy Warhol, his new favorite became Amanda Lear, a transsexual model

and performer whom Dalí first met as a man in Paris. When Amanda had her surgery, she moved to London and had a fling with David Bowie. Dalí later recognized her on a stage in Barcelona, where tall and blond Amanda was doing impersonations of Marlene Dietrich, and invited her to stay with him in Port Lligat. Dalí enjoyed parading her around, fueling rumors that the two were lovers.

In 1968, Gala no longer wanted to live with Dalí, choosing instead to reside in Pubol, a small castle that Dalí had restored, painted and given to her. The two agreed he couldn't visit her without her written permission. Gala promptly turned Pubol into a love nest and often had guests and visitors. The 79-year-old Gala's last affair was with Jeff Fenholt, the main singer of the rock opera *Jesus Christ Superstar*, who was more than five decades her junior. She had a recording studio set up for him in her castle but was consequently upset that he spent too much time in it working and not enough time in her bed. Fenholt walked away, after getting rich off the paintings she gave him, to live in a million-dollar mansion on Long Island, New York, that Gala bought for him with Dalí's money.

Growing old together completely shattered what was left of their artist-muse relationship. Their health was deteriorating rapidly. Dalí was becoming increasingly de-

pressed. His ability to create art was long gone, his name had been tainted in a series of scandals with fake artwork. Gala fed him a cocktail of sedatives and amphetamines that ruined his nervous system, giving him Parkinson's-like tremors in his hands and making it difficult to walk. Some claim it was because Gala was becoming senile and no longer knew what she was doing. Some say she was trying to poison him. In 1981, 87-year-old Gala was taken to the hospital with broken ribs after he dragged her from bed in a last fit of rage. Shortly after, she had gallbladder surgery, fell and broke her femur, and finally became so depressed she stopped eating altogether.

Gala died in 1982 in Barcelona. Since she wanted to be buried in her castle in Pubol, Dalí had to break the medieval Spanish rule that prohibited moving a dead body. He had dead Gala dressed and propped up in the back of her Cadillac next to a nurse, who was instructed to pretend they were in conversation if stopped by the police. The two-hour ride from Barcelona to Pubol was the last creative project the two pulled off together.

After Gala's death, Dalí moved to her house in Pubol and went insane; a nurse reported that he made animal noises, had hallucinations and thought he was a snail. Without Gala by his side, Dalí became everyone's nightmare for seven long years: He spat on and scratched his nurses, soiled the bed to annoy them and refused to take

his pills unless they took them, too. He would refuse to eat, causing doctors to feed him through a nasal-gastric tube. Once, a fragile Dalí managed to set his bedroom on fire in a possible suicide attempt. At the age of 84, Dalí finally died of heart failure, ending one of the strangest, most passionate and productive love affairs in the history of art.

Salvador Dalí is recognized as one of the most iconic artists of the 20th century along with his fellow Spaniards Pablo Picasso and Joan Miró. He left behind a vast collection of paintings, sculptures, installations, optical illusions, films, photographs, writings and even jewelry—all bearing his signature style. Some of the most visited destinations in Catalonia, Spain, today are the three museums established in places where Gala and Dalí lived, loved and created.

14

"I worked like the devil on it because I was never sure I could put it across or I could get across to a plush night-club audience the things that it meant to me."

—*Billie Holiday*
about "Strange Fruit"

ABEL MEEROPOL AND BILLIE HOLIDAY

STRANGE FRUIT

Inspired by a photograph of a lynching, a Bronx teacher wrote a poem that he set to a mournful tune. The song was "Strange Fruit," Billie Holiday's signature number and a symbol of the Civil Rights Movement.

A t first, Billie Holiday was afraid to sing this new song about racial injustice at a time when protest music was all but unknown. When she did perform it in 1939 at Café Society in Sheridan Square in Greenwich Village (the first nightclub in New York City that welcomed an integrated audience),

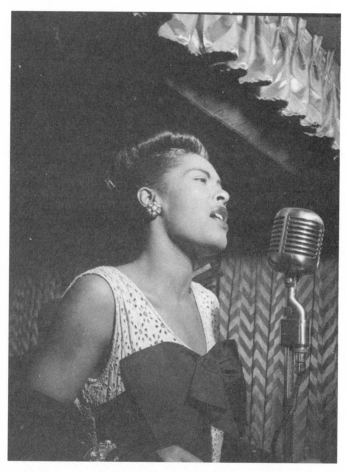

Billie Holiday at Downbeat, New York, ca. February 1947, by William P. Gottlieb

Strange Fruit
by Lewis Allan

Southern trees bear a strange fruit,
Blood on the leaves and blood at the root,
Black body swinging in the Southern breeze,
Strange fruit hanging from the poplar trees.

Pastoral scene of the gallant South,
The bulging eyes and the twisted mouth,
Scent of magnolia sweet and fresh,
And the sudden smell of burning flesh!

Here is a fruit for the crows to pluck,
For the rain to gather, for the wind to suck,
For the sun to rot, for a tree to drop,
Here is a strange and bitter crop.

"there wasn't even a patter of applause when I finished," she later wrote in her autobiography. "Then a lone person began to clap nervously. Then suddenly everybody was clapping."

Nobody who heard her emotional delivery of the haunting "Strange Fruit" would ever forget that experience. It was not just the controversial subject—the lynching of blacks in the segregated American South—but also the way she performed it, with her mournful voice evoking her own difficult life. For many, it was the striking song performed by Holiday that became the call for action in the civil rights struggle, 16 years before Rosa Parks refused to give up her bus seat in Montgomery, Alabama.

Less known is the fact that the song was written by a white Jewish man from the Bronx named Abel Meeropol.

When the English teacher, songwriter, composer and social activist saw a copy of Lawrence Beitler's photograph, "The 1930 Lynching of Thomas Shipp and Abram Smith," it disturbed him for days. He wrote a poem in reaction and published it under his pen name, Lewis Allan, in The New York Teacher, a union publication, in January 1937. He then set the poem to music. Over the next few years, "Strange Fruit" would be performed regularly at left-wing rallies by Meeropol's wife, Anne, members of the teachers' union and by assorted soloists

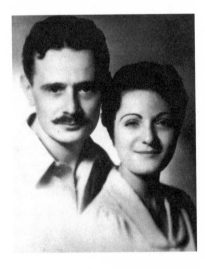

Abel with wife Anne Meeropol, the first person to sing "Strange Fruit" in public, ca. 1935

and ensembles. His protest song gained a certain success in and around New York.

In late 1937 and early 1938, Holiday was performing with the Count Basie Orchestra and touring with Artie Shaw and his band, one of the top performers in the country at the time. Holiday became one of the first black women to perform with an all-white band, but she was still subject to insults and discrimination when on tour, especially in the South, where restaurants and diners would not serve her, even when Shaw insisted on her being treated equally. In the prime of her career in 1938, many still didn't know her name, even at Harlem's Savoy Ballroom.

In early 1939, Meeropol presented "Strange Fruit" to Barney Josephson, the owner of Café Society, the only racially integrated nightclub in New York that had become a gathering place for left-wingers, intellectuals, artists, writers and jazz lovers. Josephson brought it to Holiday, who later described it as "a hell of a damn song."

Josephson prepared detailed and dramatic stage directions for "Strange Fruit." Before Holiday began to sing, all service stopped: Waiters, cashiers and busboys stood still. The lights were turned off except for a spotlight on Holiday's face. When she finished the song, even that light went out, and she left the stage. No matter how thunderous the ovation, she did not return. "Strange Fruit" became a nightly ritual and one of her signature songs. She would always sing it last and leave the stage in complete silence.

Recording the song was another challenge. After Holiday's record company, Columbia, refused to record "Strange Fruit" because of the sensitive subject and intense lyrics (and because her producer, John Hammond, did not like it), Holiday took the song to Milt Gabler, her friend and record producer, who ran his independent label, Commodore Records, out of a music store on East 42nd Street. Columbia gave Holiday a one-session release from her contract. The song was recorded in April and released that summer. The impact was immediate,

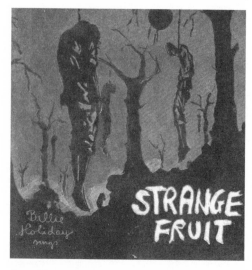

One of the
record jackets of
"Strange Fruit"

and the record sold a million copies, in time becoming
Holiday's biggest-selling record.

Holiday only sang it in certain places, avoiding per-
forming it in the South, where she was often harassed.
Once, in a California club, a man in the audience heck-
led her and yelled out racial slurs. When Holiday was
ready to walk out, Bob Hope and Judy Garland walked
in. Hope convinced her to stay, yelling at the man, until
the "sonofabitch," as Hope called him, left the club. Af-

ter the show, Hope invited her to celebrate with dinner and a "bucket of champagne."

In 1940, Meeropol was called to testify before a committee investigating communism in public schools. The committee wanted to know if the American Communist Party had paid him to write the song. Like many New York teachers in his day, Meeropol was a Communist, but he denied the song was written for any other reason than simple human empathy.

Meeropol left his teaching job at DeWitt Clinton High School in 1945 and eventually left the Communist Party. Then, he caused a stir in the media in 1953 when he and his wife adopted two orphan boys, ages 6 and 10, the sons of the infamous Julius and Ethel Rosenberg, who were executed for conspiring to give nuclear secrets to the Soviet Union. In spite of the potential consequences of this action during the Red Scare gripping America, Meeropol's sense of empathy prevailed once again.

Billie Holiday was consumed by drugs, drinking and a bad marriage. The rest of her life, after the success of "Strange Fruit" and other hits, became a theater of self-destruction. In July 1959, she died in a New York hospital, handcuffed to her bed while under arrest on drug charges. The New York Times ran a short, un-by-lined obituary on page 15. She was 44 years old and left an estate of $1,000.

Abel Meeropol passed away in 1986, leaving behind his two adopted sons, who became college professors and philanthropists.

Today, Billie Holiday is recognized as one of the most influential performers of our time. "Strange Fruit" was inducted into the Grammy Hall of Fame, named a "song of the century" by Time magazine and is listed in the National Recording Registry of the Library of Congress.

15

"I Love Lucy was never just a title."

—*Desi Arnaz*

LUCILLE BALL AND DESI ARNAZ

A DIFFERENT KIND OF LOVE

Inspired by their real-life marriage, Lucille Ball and Desi Arnaz became Hollywood's unlikeliest power couple by creating one of the most successful television shows in history and changing the television industry in the process.

I Love Lucy is considered one of the most influential sitcoms in history—and the most loved. When the original black-and-white show ran from 1951 to 1957, four out of six seasons had the most viewers of all television programming in the U.S. America was madly in love with Lucy and Ricky—a couple who

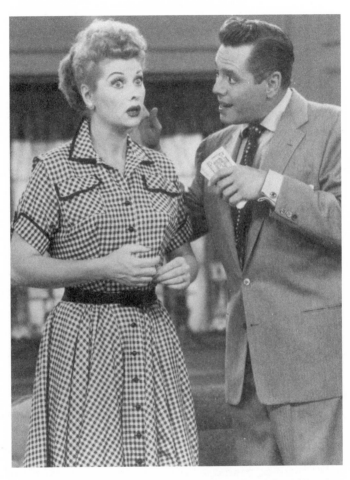

Lucille Ball (as Lucy Ricardo) and her husband, Cuban actor Desi Arnaz (as Ricky Ricardo), in an episode of *I Love Lucy,* 1954

had chemistry both on and off the screen. On Jan. 20, 1953, 29 million people tuned in to watch Eisenhower's inauguration, but the very next day 44 million people watched Lucy give birth to Little Ricky.

Lucille Ball and Desi Arnaz first met in 1940 in Los Angeles on the set of the musical *Too Many Girls*. She was an up-and-coming 29-year-old comedienne, he was a 23-year-old musician. The two fell in love instantly and were married six months later.

They could not have been more different, starting with their backgrounds. Born in 1917, Desi grew up in a distinguished Cuban family. His father was the mayor of the city of Santiago, and Desi had just about everything a 16-year-old could dream of, up to and including a speed-boat, until the affluent family lost everything after the 1933 Cuban Revolution and fled to Miami with nothing but the clothes on their back. In America, Desi worked at a series of menial jobs, including cleaning birdcages, until he made his way into the music world.

Lucille was born in 1911 to a struggling family in Jamestown, New York. Her father died when she was 4, and her mother remarried—to a man who didn't like children. The couple moved to Detroit, leaving Lucille and her brother, Fred, behind, splitting the toddlers between relatives. Lucille was placed in her step-grand-mother's unloving household. At 15, she dropped out of

high school, and after a modeling stint and a few hair color changes, the 19-year-old made it to Hollywood where she pursued an acting career, in spite of being told she'd never be anything more than a supporting star, at best.

When Desi and Lucille met, the attraction between the handsome, warm-hearted Cuban and the quirky, outgoing redhead was immediate. But they were also equally hardworking, business savvy and dedicated to their careers. After they married, Lucille continued acting in Hollywood and starred in a radio show, while Desi toured with his band. The two saw little of each other in the early years, and when they did, they fought about Desi's drinking and womanizing, which almost led to a divorce. The couple decided that instead of spending money on divorce lawyers, they should capitalize on their tumultuous and passionate union by turning it into a television show.

They began by aiming to adapt Lucille's popular radio show, *My Favorite Husband*, for television and to star in it together as a married couple. CBS was adamant that audiences would not buy a sweet all-American redhead being married to a Cuban. Undeterred, Lucille and Desi founded their own production company and named it Desilu—an amalgam of Desi and Lucy—and came up with $5,000 ($49,000 in today's dollars) to produce a

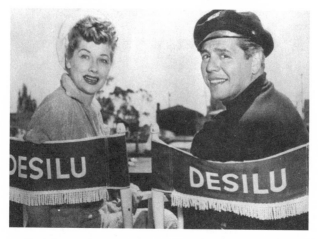

Lucille Ball and Desi Arnaz

pilot. That pilot became the revolutionary television sensation *I Love Lucy*.

Desilu went on to change many industry standards. Up until then, TV shows were produced using kinescope, which resulted in a lower-quality image that was aired only once. Desi convinced the studio to allow Desilu to pay for the cost of producing *I Love Lucy* in much higher quality on film, as long as Desilu owned the negatives. Years later, Desi sold the negatives back to the studio, giving birth to the concept of reruns, and making millions of dollars in what is considered one of the shrewdest business moves in the industry. With the help of cam-

eraman Karl Freund, Desi developed a multifilm camera setup, which is now the standard production method for live sitcoms. Their method used three cameras instead of one so that angles and close-ups could be shot at the same time and therefore provide a more captivating viewing experience. Desi is also responsible for laugh tracks as we now know them. Live audiences were not allowed at a taping prior to *I Love Lucy*, but Desi developed a set that would accommodate real-life viewers as well as meet fire, health and safety codes. In addition to all the groundbreaking technical and financial decisions made by Desi—in spite of him not having any formal training or business education—the couple also decided their show would maintain what Desi called "basic good taste." As a result, they avoided all racial jokes as well as humor based on physical handicaps or mental disabilities. The only exception was Ricky's rich accent—but Lucy was the only one allowed to make fun of it.

While Desi strengthened the family business with his business acumen, Lucille was undeniably the heart of the dynamic duo. She had an incredible knack for physical comedy. It was said that when she was telling a story, "it was wise not to sit next to her or she would use you as a prop." On set, Lucille was a perfectionist and control freak, never afraid to yell when people weren't doing what she wanted, even when those people happened to

be famous actors. Desi adored her. "Lucy was the show. Viv, Fred and I were just props. Damn good props, but props nevertheless," he later wrote in his memoir. Yet, in her mind she was just a muse to Desi, saying, "I knew that Desi wanted a wife who would play second fiddle to him, this was all right with me…I did everything in my power to advance his career, to bolster his confidence in himself…This was the way I had been brought up and this was what I wanted."

In addition to being the first television program to feature an interracial couple, *I Love Lucy* also became the first to show what was considered scandalous at the time: a real pregnant woman playing a pregnant character. When Lucille became pregnant with her second child, it was impossible to hide, so they wrote it into the script. Although the couple didn't know the gender of the baby in real life, the script had her character on the show give birth to a boy named Little Ricky. Miraculously, Lucille gave birth to a son on the same Monday night when the highest-rated episode—Lucy giving birth to Little Ricky—aired nationwide. The head writer joked that only Lucille Ball could deliver her real child exactly as per script. Lucille and Desi named their two real-life children after themselves: Lucie Arnaz and Desi Arnaz Jr.

Everyone's favorite show about a hilarious, passionate couple received numerous nominations and won four

Emmy Awards, along with the coveted Peabody Award in "recognition of distinguished achievement in television." The show also managed to change the geography of the industry: All TV production at the time was based in New York, but Desilu stubbornly refused to move away from Los Angeles and based its operations in the city it called home. Following its lead, by 1961 virtually all primetime TV would be filmed on the West Coast. Thanks to the success of the show, Desilu was the second largest independent TV production company until 1962, and then the largest until 1967, when it was sold and renamed Paramount TV.

But the dream couple eventually fell apart. Desi's heavy drinking, coupled with violent arguments on set initiated by both, drove the founders of Desilu to divorce in 1960 after two decades together. In 1962, Lucille bought out Desi's share of the company at his insistence, perhaps because he was tired of directing his now-remarried ex-wife in the show they had created together.

After the buyout, Lucille became the first woman to head a major studio, and she performed impressively in that role as well. Looking for new, innovative formats that could sustain Desilu going forward, Lucille was approached with two offers that made television history. From Bruce Geller, she received *Mission: Impossible;* and from Gene Roddenberry, *Star Trek*. Since the actual con-

cept of Star Trek was far removed from TV fare, she was advised against taking the offer. *Star Trek* was seen as too jargony, too serious for sci-fi and ultimately far too expensive, but Lucille knew better. She recognized that the show was a true original with great potential, and she was right—the series went on to outlive Desilu itself.

Among the many things Lucille and Desi created together, they were especially proud of their children, Desi Jr. and Lucie. Desi Jr. took after his famous father and enjoyed some musical success as part of the singing group Dino, Desi & Billy. Featuring the son of pop singer Dean Martin, the group enjoyed a five-year run and released six albums and over a dozen singles. Lucie found success starring in roles both on-screen and in live theater, most recently in 2014 as Grandma Berthe in the Tony-winning revival of *Pippin*, in which, at the age of 63, she had a trapeze solo.

Even after their divorce, the two remained loving and respectful of each other to their last days. Lucille's close friend Lillian Briggs Winograd said that, although Lucille was happy in her second marriage, which lasted 25 years, it was "a different kind of happiness." The couple's love and inspiration for each other was perhaps best expressed in Desi's last words to Lucille before he died in 1986: "I love you too, honey. Good luck with your show." Lucille passed away three years later in 1989.

Both Lucille Ball and Desi Arnaz have been honored with two stars each on the Hollywood Boulevard Walk of Fame, one for contribution to the television industry and one for motion pictures. In addition to the many awards Lucille received during her lifetime, she was awarded several posthumously, including the Presidential Medal of Freedom in 1989. In 2001, the U.S. Postal Service honored her with a commemorative stamp on what would have been her 90th birthday. She is often credited with paving the way for female comedians like Tina Fey, Melissa McCarthy and Julia Louis-Dreyfus.

In September 2015, it was announced that the couple's two children planned to produce a feature-length film about the lives of their parents, with Cate Blanchett to star as Lucille.

I Love Lucy is still syndicated in dozens of languages around the world and attracts 40 million viewers a year in the U.S. alone, more than six decades after its first run.

16

"To all the devils, lusts, passions, greeds, envies, loves, hates, strange desires, enemies ghostly and real, the army of memories, with which I do battle—may they never give me peace."

—Patricia Highsmith's diary, 1947

PATRICIA HIGHSMITH

DARK MASTERMIND

Inspired by her dislike of humanity, the antisocial author wrote best-selling thrillers that became the material for several Hollywood hits filled with murders and schemes.

I f ever there was a creative person driven by the power of sheer misanthropy, it was Patricia Highsmith. Highsmith is known for her many psychological thrillers that have been turned into Hollywood hits—two dozen in all, along with television and radio adaptations. Her very first novel, *Strangers on a Train,* about two men making a murderous pact was published

Patricia Highsmith, ca. 1965

Alain Delon as Tom Ripley in *Plein Soleil*, 1960

in 1950 and immediately attracted the master of thrillers, Alfred Hitchcock. The film became a Hollywood classic and made Highsmith famous. Her five-book series about Tom Ripley, known as *Ripliad*, was turned into several movies. The character of Tom Ripley, an orphan turned sophisticated con artist and ruthless serial killer, has been played by such respected actors as Alain Delon, Dennis Hopper, John Malkovich and Matt Damon. Highsmith

was gifted at writing stark prose featuring characters who lie, stalk and murder in cold blood, as well as characters who lead double lives or feel like orphans.

Perhaps, it was because all her life Patricia Highsmith felt like both.

Highsmith was born Mary Patricia Plangman in 1921 in Forth Worth, Texas, nine days after her parents divorced. Her neurotic mother later told her that she had tried to abort the pregnancy mid-term by drinking turpentine. Her mother remarried, but Highsmith hated her stepfather, angry because she had to share her mother's scant affection with him. Adding to her resentment and feelings of abandonment was the fact that at 12 years old she was left with her grandmother for a year. The relationship between Highsmith and her mother remained contentious for the rest of their lives.

Highsmith started writing early on. Her choice of subject matter was dark, especially for a child. In her diary, she fantasized about her neighbors hiding murderous personalities behind a facade of normality. At the age of 9, she discovered a book that would influence her writing and become her favorite for decades to come: Karl Menninger's *Human Mind*, a collection of case histories of mental illness and deviant criminal behavior. She was also proud to be born on the same day as the master of the noir genre, Edgar Allan Poe. In addition to writing,

she discovered another way to cope during her teenage years—drinking.

At Barnard College, where Highsmith went to study writing, she wrote and published a story about an orphan boy found and adopted by convent nuns, who concealed his gender, named him Mary and raised him as a girl. The boy grows to be an evil genius, who attempts to escape the convent by blowing it up. Highsmith illustrated the story with her own drawings, in which the little boy looked exactly like herself. The boy's name was not accidental: Mary was her name at birth and also the name of her mother. It was a seminal story for Highsmith's storytelling style.

Highsmith's first relationship was with a woman, and it was followed by many more. She described one of them in her diary as "my green and red goddess, my jade and garnet, my moss and hollyberry, my sea and sun, my marrow and my blood." She also tried to form a relationship with novelist Marc Brandel, to whom she confessed both her mother issues and her love of women. He didn't mind, but Patricia began undergoing psychoanalysis in an effort to get herself "into condition to be married." The therapy didn't work. In her letters to her stepfather, she described, in horrid detail, her absolute repulsion over being intimate with Brandel. Highsmith had many more relationships throughout her life, mostly

with women, some with men, but she never married or had children.

She put all her passion into writing disturbingly dark prose: a delivery boy who kills the staff at a local wax museum and puts their bodies on display; an accountant, driven insane by his child's Down syndrome, who chokes a stranger to death; a man gone delusional and murderous over a woman who doesn't return his feelings. An agent once complained that her books were difficult to sell in America because the people in them were unlikable. Highsmith remarked that it was natural, as she didn't like anyone either. In 1975, Highsmith published a story collection titled *The Animal-Lover's Book of Beastly Murder*, featuring animals—from an elephant to a cockroach—which take revenge on the human race. It was a great follow-up to her truly bizarre snail-centric stories: *The Snail-Watcher,* which had taken her 12 years to get published, and *The Quest for Blank Claveringi*, both of which don't end well for their human protagonists.

Highsmith actually preferred snails to people. After moving to Europe, she bred hundreds of snails in her house in England, and once showed up to a party carrying a head of lettuce with a hundred snails in it—her preferred party companions, she made sure to tell everybody. Highsmith never concealed her ever-growing disdain for humanity—she was described by some contemporaries

as "the most cruel, rude, persistently ugly human being." She could really hold a grudge, too. After resuming correspondence with a former lover, Highsmith showed up on the woman's porch drunk and ranting—27 years after the two had broken up. She was also racist and anti-Semitic, once inventing about 40 aliases to slam Jews in newspaper articles, in spite of having very close Jewish friends. She called feminists "whining," and she hated America as a whole, writing a notoriously anti-patriotic collection of stories titled *Tales of Natural and Unnatural Catastrophes.* She spent the last 32 years of her life in Europe, but kept her U.S. citizenship and complained about having to pay American taxes. Later in life, she picked up woodworking and spent hours in the woodshed, developing a hump on her back and calluses on her big, square hands, while seeming to turn into a character who could belong to one of her favorite authors—be it Poe, Kafka or Dostoyevsky.

As prolific as she was antisocial, Highsmith produced 22 novels and eight short-story collections. Only one of them was a happy story, a story where love prevails. *The Price of Salt* was the only Highsmith novel where nobody dies, and the only novel she didn't publish under her own name.

The Price of Salt was inspired by a real event. As a young woman, Highsmith was working part-time as a shopgirl in Bloomingdale's to supplement the income

from her comic-book writing, when she saw a beautiful, rich older woman come into the store to purchase a doll for her little daughter. The two women never met again. That same night, Highsmith went home and wrote the outline for the book. A young shopgirl, Therese, meets rich, beautiful and older Carol in Bloomingdale's, and the two set off on a journey of love, both literally and figuratively. Highsmith published *The Price of Salt* in 1952 using the pseudonym Claire Morgan to avoid being labeled a "lesbian writer."

Like all of her work, the story is rich in language and imagery, and points to Highsmith's many unresolved internal conflicts. While it's a love story between two women, Highsmith's longing for her own mother's affection seems to be a hidden motif. When young Therese comes to Carol's home for the first time, Carol offers her a glass of warm milk, which Highsmith described as tasting of "bone and blood, of warm flesh, saltless as chalk yet alive as a growing embryo." The book became a success, but Highsmith denied her authorship until the early 1990s.

In 1995, Patricia Highsmith died a recluse at the age of 74 in Switzerland, surrounded by her books and cats. She left her entire estate and future royalties to Yaddo, the writers and artists colony in upstate New York, where she'd spent part of the summer of 1948 working on *Strangers on a Train*.

Carol, Rooney Mara and Cate
Blanchett, 2015

In 2015, *The Price of Salt* was turned into the criti-
cally acclaimed movie *Carol*, starring Cate Blanchett as
Carol and Rooney Mara as Therese. The film made its de-
but at the 2015 Cannes Film Festival to glowing reviews.
It received six Academy Award nominations, including
Best Actress (Blanchett) and Best Supporting Actress
(Mara). It also dominated the New York Film Critics
Circle Awards, earning Best Film, Best Director (Todd
Haynes), Best Screenplay and Best Cinematography.

Thanks to the film's success, new generations of moviegoers and readers have discovered the great body of work of Patricia Highsmith, a master of all things murder and love, and quite possibly the biggest character of them all.

17

"Mom always said: don't be pushy, but always let everybody know you are around."

—*Andy Warhol*

ANDY WARHOL

THE GENESIS OF A GENIUS

Inspired by his immigrant mother who encouraged his art, the artist went from humble beginnings to international fame, creating art that was influenced by his family background and his view of American culture.

A ndy Warhol is one of the most famous American artists of the 20th century, recognized as the creative genius behind the Pop Art movement, a prominent symbol of the New York art and culture scene, and the godfather of the instant celebrity phenomenon. His rule-breaking art—loved by some,

Andy Warhol about the age of 3,
with his mother, Julia, and brother
John, 1932

detested by others—continues to command record-breaking prices: In 2009, his experimental 1962 work *200 One Dollar Bills*, a vast 20-by-10 grid of $1 bill images, sold for $43.8 million at Sotheby's, and a portrait of Mao Zedong recently went for $47.5 million.

Andy Warhol was always inspired by celebrities, and they loved being his subjects. Everyone who was anyone at the time posed for his private point-blank Polaroid collection: Diana Ross and Dennis Hopper, Joan Collins and Muhammad Ali, Dolly Parton and Jimmy Carter, Giorgio Armani and Farrah Fawcett, and, fittingly, himself in his signature platinum wig and dark sunglasses. His painted portraits of Marilyn Monroe, Elvis Presley, Jackie Onassis and Liza Minnelli elevated their already famous faces to a whole new Warhol level.

Warhol's New York art studio, which he named The Factory, was the epicenter of his universe built on flamboyant personalities, innovative ideas and creativity. A master of publicity, Andy Warhol had the power to make celebrities simply by welcoming people into his circle. His entourage was as colorful as his art: Film and stage actors, dancers, performers, musicians, artists and filmmakers—straight, gay, transgender and ambiguous—formed a whole new category known as Warhol Superstars.

A true original, an artist of the kind never seen be-

fore, Andy Warhol was one of the most enigmatic and controversial American celebrities of the century.

Yet, he came from humble roots.

Andy Warhol was born Andrei Warchola in 1928 to immigrant parents, Ondrej and Julia, in unglamorous Pittsburgh. His parents had journeyed to America in search of a better life from the tiny village of Miková (population 158) in today's Slovakia. The Great Depression hit America right after their arrival. The family moved five times in Andy's first six years of life. Julia took care of the three children while Ondrej worked construction jobs and as a coal miner. They were so poor that the three brothers slept in the attic so the family could rent out the main living space to tenants. At 6 years old, Andy fell and broke his right wrist, but the family couldn't afford a doctor and they just let it heal. It healed crooked, and later a doctor had to break the arm again and reset it.

In 1934, Ondrej managed to buy a brick house for the family at 3252 Dawson Street in the Oakland section of Pittsburgh. He chose the house based on the two things he cared about the most: It was within walking distance to a school and to a Byzantine Catholic church. The family attended church regularly, and Warhol kept an altar with a crucifix and a well-worn prayer book throughout his adult life. Art critics have pointed out that it was the gold-faced Byzantine icons found in Eastern European

Orthodox churches that later inspired Warhol's famous celebrity portraits.

Warhol's first and most influential muse was his immigrant mother Julia. She taught him the art of her native Carpathian roots: simple yet colorful embroidery and intricate patterns painted on Easter eggs. She enjoyed singing her native folk songs. She loved to make bouquets of flowers by cutting up tin cans. When Andy was bedridden in the third grade with chorea, a nervous disorder that also left him with scars on his face, Julia filled his time with what few coloring books and painting supplies she could afford, encouraging his talent to grow. She taught him to draw, to paint, to print images. At 8 years old, Andy wanted a movie projector, but his father couldn't spare the money for it. So Julia picked up some cleaning work in the city, once or twice a week, until she saved 10 dollars to get Andy the projector. She got him his first Kodak camera when he was 9, and Warhol started developing his own images in the makeshift darkroom in the basement. At this time, Andy also began to collect pictures of singers, actors and other celebrities that he would cut out from old magazines.

Education for their children was paramount for Ondrej and Julia. Julia managed to arrange for fourth-grade Andy to attend free Saturday morning art classes at Carnegie Institute with a highly respected art teacher, Jo-

seph Fitzpatrick. Fitzpatrick recognized Andy's talent early on, frequently putting him on the honor roll. Warhol continued to take these classes for four years, developing his unique style. He remained an odd kid out: His only friend in the class of over a hundred kids was Nick Kish, a son of Hungarian immigrants whose parents had moved to America from a small village only 60 miles away from where the Warcholas came from. The two stayed out of the trouble that all the other kids seemed to get into on the streets by drawing together in each other's home.

When Andy was 13, his father fell ill after drinking tainted water at a construction site. It took Ondrej six painful weeks to die. His final wish was for Andy to continue his education. Ondrej's life savings were put toward Andy's tuition at the Carnegie Institute of Technology (now Carnegie Mellon University), where he earned a degree in Pictorial Design with the goal of becoming a commercial illustrator. Andy moved to New York shortly after graduation in 1949 and started illustrating for such magazines as Glamour, Harper's Bazaar, Vogue and The New Yorker. In his memoirs, Warhol describes the strongest memory he had from those years was living in cockroach-infested apartments. He wrote about showing his portfolio to Harper's Bazaar when a cockroach fell out of his artwork, making the editor give him a job "out of pity." While he was destitute trying to make it in New

York, Julia kept mailing him money, a few dollars at a time. Warhol went on to win several awards from the Art Director's Club and the American Institute of Graphic Arts for his work. His creative interests kept expanding, slowly growing into what is known today as the Andy Warhol legacy.

Warhol garnered the most attention—and criticism—for turning mundane, everyday objects, like Campbell Soup cans and Coke bottles, into objects of art. He responded that these were the great equalizers in American society: Whether you were a celebrity or a blue-collar worker, a can of soup or a bottle of soda cost you the same and, as such, were quintessential symbols of American life. His unique outlook was undoubtedly inspired by growing up poor and being an outsider.

Julia remained a source of strength for her son. In 1951, widowed Julia moved in with Warhol, who was 24 at the time, and took care of him for the rest of her life. She was more than a caretaker—Julia continued to inspire her talented son. While Warhol's reputation was increasing in the art world, at home he and Julia were working on very special projects of their own.

The two shared a love of cats. True to her Eastern European village upbringing, Julia always kept cats in the Warchola household. Many of them came and went over the course of Andy's childhood. In 1954, the two

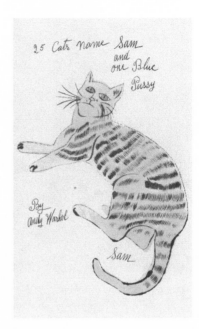

25 Cats Name Sam and One Blue Pussy

collaborators produced a privately printed, limited-edition artist's book titled *25 Cats Name Sam and One Blue Pussy*, with calligraphy by Julia and lithographs of family cats produced using Warhol's own blotted-line technique. Julia omitted the final "d" in the word "named," but Warhol chose not to correct the title, enjoying the small imperfection. The two went on to produce a few more books, focusing on all the things Julia adored: cats, angels and, combining both in one, holy cats. Throughout her life, Julia's English retained a very thick accent

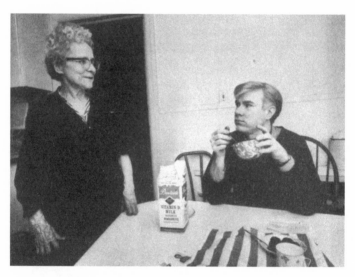

Andy Warhol eating cereal and
looking at his mother, Julia

and she spoke mostly in the present tense. Andy would
sometimes switch to their native dialect to help a con-
versation along. In spite of having trouble with the Eng-
lish language, her calligraphy was beautiful and whimsi-
cal, and she often signed Warhol's artworks for him. In
1958, Julia won an award from the American Institute of
Graphic Arts for an album cover for *The Story of Moon-
dog*, composed of a long inscription in alternating purple,
green and blue ink. Warhol was immensely proud of her
achievement.

In the 1960s, Warhol branched out into record producing, publishing and filmmaking. His avant-garde films featuring strange and beautiful people immediately became underground cult classics. Naturally, he made one about his mother. In 1966, Andy produced a movie *Mrs. Warhol* in which Julia, always up for a creative project to do with her son, played an aging movie star with multiple husbands. Warhol wielded his creative power to transform his mother from a thickly accented, religious immigrant housewife into a glamorous woman deserving of the camera's attention.

In the 1970s, Warhol's fame as a bona fide star of the art and pop-culture scene continued to expand. His friends and subjects included the likes of Truman Capote and Jacqueline Kennedy Onassis. Commissioned celebrity portraits became his mainstay. In 1972, Julia passed away. Her last words to Andy's older brother Paul were: "Promise me you'll take care of Andy." Warhol was so devastated, he couldn't even bring himself to attend his mother's funeral. Two years later, he canonized her, painting Julia in his signature celebrity-portrait style.

In the 1980s, Andy Warhol reached the peak of his popularity. His television shows were broadcast on New York cable and on MTV. He was featured on *Saturday Night Live* and even appeared on an episode of *The Love Boat*. He participated in fashion shows and TV ad cam-

paigns. He collaborated with the rising stars of the art world, including Jean-Michel Basquiat and Keith Haring. His exhibitions ran in Milan and New York.

When Andy Warhol died in 1987, it was a media event of the year. His passing was commemorated by front-page coverage in the New York Times. A memorial service held at Manhattan's St. Patrick's Cathedral was attended by 2,000 people, including movie stars, musicians, fashion designers and other celebrities. But Andy Warhol wasn't there. He had already gone home.

In accordance with his will, Andy's body had been taken to Pittsburgh, where he was given a traditional Byzantine Catholic ceremony and buried—in his black cashmere suit and platinum wig—in an unassuming Catholic cemetery on the outskirts of the city next to his mom and dad.

18

"My favorite thing is to go where I've never been."

—Diane Arbus

DIANE ARBUS

WONDERLAND OF OTHERS

An artist inspired by otherness, Diane Arbus became a pioneer of documentary photography by focusing on unorthodox subjects avoided by mainstream culture, creating a unique world of her own.

Known for her startling portraits of so-called "freaks"—nudists, transvestites, circus performers, people with mental and physical conditions, and other misfits—Diane Arbus remains a contradictory figure. Critics have denounced her for being an affluent outsider exploiting those living on the

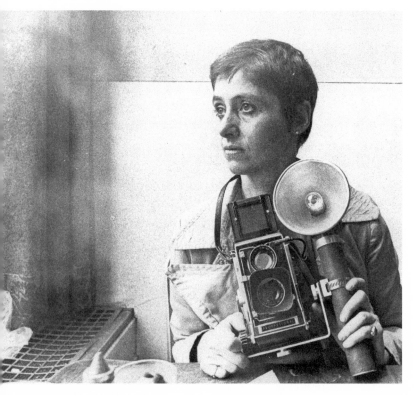

Diane Arbus, ca, 1968

fringes of society, while her subjects often accepted her as one of her own.

Diane Arbus was born Diane Nemerov into an affluent Jewish family in Manhattan in 1923. Her parents owned Russeks of Fifth Avenue, a department store specializing in furs. The family lived in lavish apartments, with domestic help, at prestigious locations around New York's Central Park. Together with her siblings, she enjoyed a privileged upbringing, and once described a childhood memory of her nanny not allowing her to take off her white gloves while playing outside. Inherited wealth protected the family from the impact of the Great Depression while she was growing up. It was this very upbringing that she later said was a source of inspiration for her interest in life outside her comfort zone. She suffered from a lack of adversity and felt confined by a sense of unreality.

At age 14, Diane fell in love with Allan Arbus, a 19-year-old nephew of her father's business partner. The family was against the romance, but the young couple continued it in secret, until they got married four years later after Diane turned 18. Her family was forced to accept it. When the two developed a shared love for photography and turned a bathroom in their apartment into a part-time darkroom, Diane's father gave them work shooting advertisements for Russeks. The couple went

on to take advertising photos for many clients, ranging from Greyhound bus lines to Maxwell House coffee and Glamour magazine. Even though Allan was the photographer and Diane the set stylist, the relationship was mutually supportive and all the credit was shared. It was Allan who gave Diane her first camera and encouraged her to develop her talent. When a photograph of theirs was accepted into a MoMA exhibition in 1956, he backed her decision to pursue her own artistic vision, leaving the family photography business to him.

On her own, Diane discovered that she was drawn to the world that was the exact opposite of meticulously styled, high-fashion photography: the nonconformist, the imperfect, the rarely seen. Inspired by a photography course with photographer Lisette Model and the support of her friend and mentor Marvin Israel, Diane set out to pursue her subjects. A shy, quiet person during the day, she was happiest at night, roaming the dark streets of New York by herself and befriending people most wouldn't dare to approach. From the hearing-impaired frequenting the Apollo Theater in Harlem to the bag ladies in Grand Central Terminal in Midtown to her favorites, the performers at Hubert's Museum (known for freaks and sideshows) in Times Square, Diane felt both scared and exhilarated by entering worlds that were nothing like her own.

Among her new subjects was Moondog, a giant bearded and blind beggar working a corner in his horned Viking helmet and strange homemade outfit. In a city full of homeless, most would avoid a man of his stature and appearance. But Arbus struck up a friendship, and the two spent days getting to know each other. She learned he was actually a well-known New York street musician and inventor. Eventually, he agreed to let her photograph him on one condition: She would have to spend the night at his cheap motel, which she did. She said later that photographing a blind subject was excitingly different because, unlike fashion models, he acted natural and didn't try to change his facial expressions for her, since he didn't know what they were.

In 1959, shortly after their professional separation, Diane and Allan divorced. They remained close friends, but Allan later said he felt that their divorce might have propelled her development as a photographer even further, as he never would have felt comfortable with her going to the places she did in search of her subjects.

Getting to know her subjects first before turning her camera on them became her signature approach. She first met Eddie Carmel, known as the Jewish Giant, when following traveling circus acts around the country in the 1960s, but it wasn't until 1970 that she took the startling photo titled *A Jewish Giant at Home With His Parents in*

the Bronx, N.Y. 1970. It made Eddie famous and became an important part of her own legacy. Before finally arriving at the seemingly mundane moment when the photograph was taken inside his parents' apartment, Arbus spent years immersing herself in the family's life, from Carmel's complicated relationship with his parents to his rare gift of composing poetry based on a given word or an idea to his love of money (he demanded payment for photographs). Arbus had an even longer relationship with Lauro Morales, another one of her now famous subjects, whom she met in 1957 and photographed for years until she took the portrait titled *Mexican Dwarf in His Hotel Room, N.Y.C. 1970.* Marvin Israel later said that for Arbus those photographs were more than artworks, they were trophies of the authentic experiences she had with her subjects.

Arbus never concealed the fact that these encounters both terrified and excited her, as she yearned to venture outside her safety zone. "There's a quality of legend about freaks," she said. "Like a person in a fairy tale who stops you and demands that you answer a riddle. Most people go through life dreading they'll have a traumatic experience. Freaks were born with their trauma. They've already passed their test in life. They're aristocrats."

Throughout the 1960s, Arbus continued to work as a commercial photographer as well, and her portraits of

the intellectual elite—actors, activists and writers—for such magazines as Esquire and Harper's Bazaar began to reflect her personal style. Even though her subjects were often depicted in settings in which they felt comfortable, the energy of each portrait was uniquely intense, because even for her commercial work Arbus insisted on talking and listening to her subjects for hours, following them home or to the office, warming them up until they dropped the public facade and revealed themselves to her camera.

Diane Arbus went on to create a vast array of unforgettable portraits: the scandalous *A Naked Man Being a Woman*; the touching *The King and Queen of a Senior Citizens' Dance, NYC*; the arresting *Identical Twins, Roselle, New Jersey, 1967*; the controversial *Child With Toy Hand Grenade in Central Park, New York City, 1962*; the strangely disturbing *A Very Young Baby, NYC 1968* (the subject of which grew up to be CNN anchor Anderson Cooper); a drag queen at home in curlers with a cigarette; an albino sword swallower at a carnival; the untitled portraits of patients in mental institutions and residents of a nudist colony; a Russian dwarf performer who claimed he "had five wives of regular size;" and many more. When asked how she picked her subjects, Arbus once said, "I really believe there are things nobody would see if I didn't photograph them."

The big question that remained was why did all these people allow her—a shy, petite woman with a childlike voice—into their lives, living rooms, bedrooms and changing rooms? Why did the the decision makers at mental institutions or the nudist colony trust this person with a camera? Her artist friend Paul Resika claimed she "had a way of listening that drew people to her like flies to honey." A fellow photographer Joel Meyerowitz swore that Arbus could hypnotize people: "She would start talking to them and they would be as fascinated with her as she was with them."

After a lifelong battle with depression, Diane Arbus committed suicide in her apartment in 1971 at the age of 48. Marvin Israel found her body the next day. There were rumors that Arbus had set up a camera and photographed herself dying as she took barbiturates and slit her wrists, but the police never found any evidence of that.

The next year, MoMA held a traveling retrospective of her work, which, for the next three years, became the most attended solo photo exhibition in the museum's history. The 1972 *Diane Arbus: An Aperture Monograph,* containing 80 photographs and edited by Marvin Israel and Doon Arbus, her oldest daughter, went on to become one of the best-selling art books in history. The same year, 10 photographs by Arbus became the first works by an American photographer to be exhibited in

the prestigious Venice Biennale, thus bringing her name to the attention of the international art world.

Art critics heralded Arbus as a pioneer of unorthodox beauty, or as one critic called her, "a wizard of odds." Other critics dismissed her work as being driven by sensationalism, some called her a bored affluent person exploiting the marginalized, and some used her suicide to argue that she was just a depressed person seeking to numb her own pain by witnessing the hard life of others. Her photographs, however, have withstood the test of time. In spite of today's excess of shocking images, along with advancements in photographic techniques and the proliferation of unorthodox subjects, four decades after her death the eerie portraits by Diane Arbus stand out for their raw energy, unflinching sincerity and the evident relationship between the subjects and the photographer.

The life and art of Diane Arbus predictably inspired many attempts to produce a feature film about the artist, but only one project came to fruition, when Lawrence Shainberg directed and produced in 2006 *Fur: An Imaginary Portrait of Diane Arbus*, based on Patricia Bosworth's highly praised 1984 biography.

Shainberg, who grew up with Arbus photographs in his Manhattan home and with stories told by his uncle, one of Arbus' close friends, turned his lifetime fascination with the artist into an entirely different kind of film.

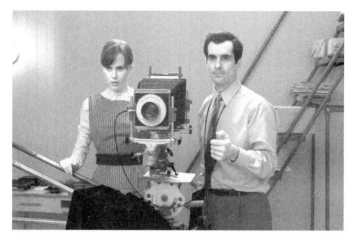

Fur: An Imaginary Portrait of Diane Arbus, Nicole Kidman as Diane Arbus and Ty Burrell as Allan Arbus, 2006

Instead of recreating the chronological events of her life, Shainberg focused on trying to discover the inner portrait of the artist. Beautifully designed and with the whimsical quality of a fairy tale, the film starts at the moment when Diane turned from being her husband's assistant into an artist with a camera, seeking and discovering her own rabbit hole of adventures. Inspired by the material, two Hollywood superstars joined the project: Nicole Kidman as Diane Arbus and Robert Downey Jr. as an imaginary upstairs neighbor named Lionel, a circus performer with a rare medical condition that left him fully covered in

Ghost twins in *The Shining* by
Stanley Kubrick (1980), inspired by
Identical Twins by Diane Arbus

hair. Lionel opens the door to a whole new world for curious Diane. Although not factually accurate, the film takes viewers on a fantastic journey into the creative mind of an artist, which can be both inspiring and scary at the same time.

By 2016, every major art museum in the world had exhibited work by Diane Arbus, with MoMA describing her in its 2005 exhibition overview as nothing short of "legendary." Her portraiture style inspires countless attempts by fans worldwide to imitate her. Every new monograph of Arbus portraits immediately becomes a

best seller, and to everyone's joy, the Arbus family contin-
ues to slowly release groundbreaking, previously unseen
work by the artist who learned to see the whole world as
her own secret fairy tale.

19

"Until I started being Rain Man, I couldn't look a person in the eyes."

—*Kim Peek*

KIM PEEK

BECOMING RAIN MAN

Inspired by his meeting with a savant, a screen-writer developed a film that changed the public's view of people with special mental abilities, as well as the real life of Kim Peek who inspired him.

The impact of the movie *Rain Man* is a great example of the power of Holly-wood: Not only was the story inspired by a real person, the film's success gave a whole new life to the very person who inspired it.

Rain Man starred Tom Cruise and Dustin Hoffman as two brothers—one self-centered, the other extraordinary—on a

Rain Man, Dustin Hoffman and Tom
Cruise, 1988

cross-country journey, which taught them how to be a winning team. The film earned eight Oscar nominations and four wins in 1988, including Best Picture, Best Director, Best Original Screenplay and Best Actor for Dustin Hoffman's portrayal of the autistic brother, but most importantly it helped humanize people with autism in the public consciousness.

Nobody expected the movie to become a hit. Released alongside the explosive action blockbuster *Die Hard* and the innovative, sexy *Who Framed Roger Rabbit*, *Rain Man* was a dialogue-driven movie about a character not many in the audience could relate to. Neither "autistic" nor "savant" were terms widely familiar to the public at the time. Still, *Rain Man* went on to generate immense success—not only in the U.S., but also worldwide, surprising everyone involved: When Hoffman visited Japan to promote the film, he was overwhelmed by the crowds of screaming fans.

The character of the autistic brother was inspired by a real person, Kim Peek. The screenwriter, Barry Morrow, met Kim in 1984 at a medical conference and was blown away. Savant syndrome is defined as having extraordinary abilities in some specific areas of knowledge, usually balanced out by the lack of 'normal' social skills, which also defines autism. Only a few autistic people are savants, and nobody knows what causes either condition.

Kim wasn't autistic, but he was a savant. Actually, Kim was a "mega-savant," whose abilities baffled even those in this niche field of study. He was definitely unlike anyone Barry Morrow had ever met.

Kim Peek was a walking encyclopedia, calendar, GPS and phone book rolled into one. He could read both sides of a book simultaneously, each with one eye, and retain 90 percent of the information read—forever. Kim could instantly provide directions between any two points in North America, cite any ZIP code in the country, answer what day of the week was any date in history, recall sports trivia, a Bible reference, a line from Shakespeare or any fact from the wide range of the world's politics or musical history. Most savants show incredible knowledge in one or a couple of these fields. Kim was unbeatable in 15 different areas of knowledge. They called him "Kim-puter."

The flip side of being a mega-savant was a whole range of physical disabilities. Kim was born in 1951 in Salt Lake City, Utah. When he was a baby, his head was 30 percent larger than normal. Kim was diagnosed as "mentally retarded" in five minutes by a doctor who was running late for a golf game. Kim crawled around pushing his head on the floor like a plow until age 4. He couldn't manage stairs till age 14; his father, Fran, had to carry him up and down them in his arms. Mean-

Kim Peek, 2007

while, Kim looked up his first word in a dictionary—
"confidential"—at 3 years old, and it took him 30 sec-
onds to find the right page. By age 6, he had memorized
the entire index of a set of encyclopedias. Nevertheless,
Kim was expelled from first grade for his inability to sit
still, and the principal advised his parents to keep him
home "where children like him belonged." Shortly after,
another doctor advised a lobotomy to "fix" Kim's person-
ality. Through it all, his father stayed faithfully by Kim,
satisfying his son's insatiable thirst for knowledge by
feeding him endless books, periodicals and all the read-

ing material the local library could provide.

Kim finished his high school's curriculum by age 14, but was not given an official diploma. In 1970, 19-year-old Kim was invited to Utah to participate in the first Special Olympics. While running a 50-yard dash with two other participants in wheelchairs, Kim looked back as he approached the finish line and realized that the girl's wheelchair was stuck against a wall, while the other boy was pushing his chair in the wrong direction. Kim turned around and rushed back to help the girl maneuver her chair to the finish line. She finished second, the other boy finished first. Kim finished in third place, and the world got its first taste of Kim's special spirit.

Before *Rain Man*, 37 years of Kim's life passed mostly between his home, the library and clinical meetings. Kim grew from a reclusive child to a deeply introverted adult. He didn't like strangers, he wasn't easy to communicate with, and he didn't understand the concept of humor. He made a lot of sharp loud noises unexpectedly. He liked to pace the room. Most people were uncomfortable around him, especially in tight spaces. His only friend was his dad, always by his side. Yet Kim could talk for hours on the subjects he loved—and his depth of knowledge was mesmerizing. One expert on savants called him "the Everest of memory." Kim Peek was, undeniably, a miracle of nature.

When Barry Morrow met Kim, he knew instantly that he had a hero for his next story. The final script of *Rain Man* was only partially based on Kim: Unlike him, the movie character was autistic, his talents and disabilities were greatly simplified when compared to Kim's, and most of the story line was pure fiction. Nonetheless, the movie achieved its intended goal: Public awareness of autism and the complexity of mental health issues soared to a whole new level.

In his Oscar acceptance speech, Dustin Hoffman thanked Kim Peek and the autistic people who had helped him prepare for the role. Barry Morrow went further and gave his golden statuette to Kim and his devoted father. A spontaneous group hug took place in Barry's house when he insisted Kim and Fran take his Oscar. They were a team, said Morrow, and they should share the Oscar—and Kim's story—with the world. "Together we are forever, Barry," replied Kim.

That's when the story took another unexpected turn. Kim and Fran began touring the country, inviting the public to witness Kim's incredible talents by asking him an impossibly wide range of questions that he was only too happy to answer. People couldn't get enough of Kim, his story and the Oscar: More than 400,000 people took a picture with Kim, his father and the golden statuette—the most unusual trio in all of show business and,

by Fran's estimate, the most-loved Oscar of all time.

The outpouring of public love and acceptance resulted in extraordinary changes in Kim: He became something of a showman, learning to enjoy being around strangers, a character trait unheard of in either savants or autistic people. He became more self-aware. At a presentation at Oxford University, a student asked if he was happy. "I'm happy just to look at you," Kim replied. His coordination improved so much he started playing piano. He even learned to make puns. Inspired by positive public interest, Kim and his dad became outspoken and active advocates for mental health research. Kim considered his new public role as an honor.

Kim Peek passed away suddenly from a heart attack in 2009 at the age of 58, after having an incredible life that not only inspired a Hollywood hit, but also propelled innovative research into the human brain. His father outlived Kim by five years and left behind two books and countless articles about his son, aiming to promote understanding of people with special mental abilities.

20

"Always remember: your focus determines your reality."

—*Star Wars: Episode I*
The Phantom Menace

GEORGE LUCAS

Maker of the Universe

Inspired by a near-fatal racecar accident, George Lucas decided to pursue his passion for memorable stories and went on to create the most successful film franchise of all time.

On June 12, 1962, in Modesto, California, an aspiring racecar driver, 18-year-old George Lucas Jr., was in a near-fatal crash. By all accounts, he was not supposed to survive the accident, but he did. That crash, however, initiated a chain of events that led to the creation of the biggest movie franchise in history—*Star Wars*.

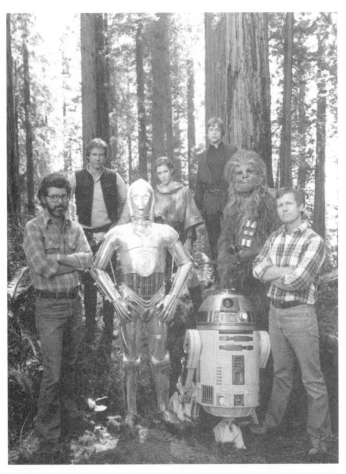

Star Wars: Episode VI—Return of the Jedi, 1983, from left; George Lucas, Harrison Ford, C-3PO, Carrie Fisher, R2-D2, Mark Hamill, Chewbacca, Richard Marquand (director)

All through high school, George Lucas competed in underground races and hung out in garages, but the accident turned him from racecars to an eight-millimeter camera. Surviving the crash gave him a new sense of purpose, an inspiration to live life as if every day was given to him as a present—and what Lucas wanted to do was tell stories.

When Lucas enrolled in the University of Southern California's film school, his unique vision became apparent early on. His 1967 student short, a science fiction entitled *Electronic Labyrinth: THX-1138 4EB,* was set in a dystopian future. The dark story about life in a bleak underground city, where technology is used for mind control, won first prize at the National Student Film Festival in New York City and attracted the attention of Steven Spielberg, who would become a lifelong friend and collaborator. In an unprecedented move, the 15-minute short was picked up by Warner Brothers and turned into a 1971 theatrical feature, *THX-1138*, directed by Lucas under the tutelage of Francis Ford Coppola. Among other characters, the film featured android cops and robed monks.

During the production of *THX-1138*, Coppola challenged young Lucas, who was mainly interested in making films based on philosophical ideas, to write a story that would have mass appeal. Rising to the challenge,

Lucas wrote about what he knew well: cars. The resulting 1973 film, *American Graffiti*, was only his second directorial feature and the first produced by his newly formed production company Lucasfilm. It became a surprise hit. Capturing the cruising culture of the baby boom generation, the critically acclaimed film became one of the most profitable films of all time: It was produced for $777,000 and grossed over $140 million. Among the many actors who appeared in *American Graffiti* was a relatively unknown Harrison Ford in the small role of Bob Falfa, a fast driver with outlaw flair.

Only 29 years old, George Lucas proved he was a talented storyteller with great potential for commercial success. That's when he decided to pursue his most ambitious goal yet: to create a classic film about family, duty, honor and the eternal battle of good versus evil—with an impact matching that of the great westerns and pirate movies of prior generations. And he wanted to create this film in a new genre he defined as "space opera." His early plan to adapt the 1930s space adventure comic *Flash Gordon* failed when he couldn't secure the rights. Undeterred, Lucas decided to create a universe of his own and spent three years writing the script that became *Star Wars*.

Studios were unimpressed with the project. The science fiction genre was not widely popular, his characters

were deemed too varied and too strange, and everyone wished Lucas would just build on the success of *American Graffiti* with a familiar subject and a setting that would be more economical to film. Lucas refused to change anything about his vision for the new movie. After many buyers passed on the script, the project was finally picked up by 20th Century Fox, and production of *Star Wars* began in 1976.

The film was full of all the things that inspired Lucas: The Eastern concept of life energy ("prana" or "qi" in Hinduism, Buddhism and Taoism) that he came across during his Buddhism studies became the Force; the robed monks and android cops from his first film returned; and even fast driving became a plot device— but this time Harrison Ford got to speed around in a spacecraft instead of a racecar. Lucas and his team drew from endless sources of inspiration to create the *Star Wars* universe: Yoda was given Albert Einstein's eyes, while the stormtroopers were given Nazi-style helmets; Han Solo's gunslinger outfit was modeled after old western films; the lightsaber fighting scenes and even the sidekick droids were inspired by Akira Kurosawa films; the opening crawl was an homage to similar opening sequences of old *Flash Gordon* films.

The original trilogy debuted in 1977 with the first installment, known today as *Star Wars: Episode IV–A*

New Hope. It became the highest-grossing film at the time, surpassing 1975's *Jaws*. It also received 10 Academy Award nominations (including Best Picture), winning seven of them. The film gave new life to the science fiction genre. It also redefined the term "blockbuster" due to its use of computer graphics and special effects—so innovative at the time, they had to be developed by a new division within Lucasfilm called Industrial Light & Magic. The same year it premiered, *Star Wars* was selected for preservation in the U.S. National Film Registry by the Library of Congress for being "culturally, historically or aesthetically significant"— the only film selected for this honor from the 1970s. In 1977, the characters of Darth Vader and the droids C-3PO and R2-D2 were honored with a handprint ceremony in front of the iconic Chinese Theatre in Hollywood, a distinction reserved for film and television's biggest stars.

Two equally successful installments followed: *Episode V–The Empire Strikes Back* in 1980 and *Episode V–Return of the Jedi* in 1983. 20th Century Fox's stock quadrupled in price, and the trilogy turned the previously unstable studio into a creative and commercial powerhouse.

Two decades later, Lucas directed three more installments, which served as a prequel to the original trilogy. The 1999 release of *The Phantom Menace* episode was the

most anticipated film event of the year. It became the second-highest-grossing film worldwide at the time, behind *Titanic,* and the highest-grossing *Star Wars* installment up to then.

Aside from its commercial success, *Star Wars* inspired unprecedented fandom across the globe. Millions of fans pledged allegiance to the *Star Wars* universe, many referring to George Lucas as The Maker. Aside from typical film geeks, the fandom included scientists, space explorers, fashion designers, linguists and comic book writers—making *Star Wars* a cultural touchstone for a multitude of people across every culture, age group, profession and nationality.

In biology, *Star Wars* is continually referenced when naming newly discovered species. Darth Vader was the inspiration behind the name of a new shiny black beetle discovered in North America and an ominous-looking mite found in Australia. Yoda inspired the names of a purple acorn worm discovered in the North Atlantic Ocean, as well as a marine isopod found in Taiwan's waters. There are three wasp species named after Chewbacca, Darth Vader and Yoda. Han Solo, everybody's favorite space smuggler, inspired the name of a fish fossil discovered in China. The guardians of peace in the galaxy gave a new name—tetramorium jedi—to an ant species discovered in Madagascar.

The official crew poster for the International Space
Station's 45th expedition (NASA)

The franchise has also been embraced by real space
explorers. In 2007, in honor of the 30th anniversary of
the original trilogy, the actual prop lightsaber of Luke
Skywalker in 1983's *Episode VI–Return of the Jedi* was
placed on the space shuttle Discovery as part of a NASA

mission. On Feb. 12, 2015, NASA revealed its official poster for the International Space Station Expedition 45. To the delight of fans worldwide, the poster featured all six crew members dressed in Jedi robes holding light-sabers, with the mission's official logo shaped like the Imperial Star Destroyer. In December 2015, the latest installment of the franchise, entitled *Episode VII–The Force Awakens,* was transported aboard the International Space Station to allow current mission crew members, some in space for several months by then, to keep up to speed on the latest *Star Wars* developments.

It can also be argued that *Star Wars* generates an almost religious following. In 2001, an internet campaign went viral—as a result, 70,000 people in Australia, 53,000 people in New Zealand, 14,000 people in Scotland and 390,000 in England and Wales declared their religion as "Jedi" in each country's national census.

Incredibly, even the "Dark Side" of the *Star Wars* universe has numerous fans as well. Tens of thousands of registered members worldwide are united in "Vader's Fist 501st Legion," the fan club organized into military-like Garrisons, Squads, Outposts and Detachments. Dressed in self-procured costumes of stormtroopers, Imperial Forces and other villains and denizens of the *Star Wars* universe, the legionnaires appear at *Star Wars* publicity events, as well as engage in charity by entertaining un-

derprivileged children and adults, wounded soldiers and patients in hospitals.

However, the relationship between Lucas and *Star Wars* fans hasn't been without controversy. When the new trilogy was completed in the late 1990s–early 2000s, many die-hard fans detested some of the new plots and overblown characters, blaming Lucas for betraying the true spirit of *Star Wars*. When Lucas remastered the original trilogy, claiming the film was disintegrating with age, and in some cases changed the original sequence of events, the relationship between the fans and The Maker turned sour. Many accused Lucas of becoming a Darth Vader-like figure himself, repeating the central story of Luke Skywalker by changing from an idealistic young man who broke all industry rules into a corporate giant chasing profits. In response, Lucas defended his right to pursue his artistic vision. "I am the creator. I'm a George with a capital G," he protested in one of his many interviews.

By 2012, George Lucas had sold the rights to the franchise to Disney for over $4 billion and stepped aside to enjoy time with his family. The transition was not easy: Lucas called his films his "children" and commented that the new creative direction did not live up to his standards. Disney selected director J. J. Abrams to helm the first installment of a new sequel trilogy. *Star Wars: Episode*

VII–The Force Awakens picks up the story where it left off in 1983. The film featured many new young stars and even a new droid. Supported by the Disney marketing machine, the opening weekend of the new installment in December 2015 became the biggest in North American box office history, with gross sales worldwide estimated to break all records again. Legions of new fans joined the *Star Wars* universe, now spanning four decades and showing no signs of decline.

In a 2015 interview, George Lucas declared that he was looking forward to leaving *Star Wars* behind him so he could focus on what he always wanted to do: independent, innovative films not intended to be blockbusters. The same year, Disney announced five more *Star Wars* installments scheduled to premiere over the next several years, including two more episodes of the new sequel trilogy and two spin-off movies. In early 2016, some fans criticized Disney and J. J. Abrams for lacking the true artistic vision deserving of the *Star Wars* universe and began petitioning Disney to bring Lucas back to direct the upcoming installments of the franchise.

As they say in a galaxy far, far away: The saga continues.

20

BIBLIOGRAPHY

Reiss, Tom, *The Black Count: Glory, Revolution, Betrayal, and the Real Count of Monte Cristo*, Crown Publishers, New York, 2012.

Davidson, Arthur, *Alexandre Dumas (Père): His Life and Works*, Lippincott, Philadelphia, 1902.

Herald, Christopher J., *Bonaparte in Egypt*, H.H. Hamilton, London, 1962.

Maurois, André, *The Titans: A Three-Generation Biography of the Dumas*, Harper & Brothers, New York, 1957.

Wilson, Victor-Emmanuel Roberto, *Le Général Alexandre Dumas: Soldat de la liberté*, Quisqueya-Québec, Québec, 1977.

Hemmings, F.W.J., *Alexandre Dumas, the King of Romance*, Charles Scribner's Sons, New York, 1979.

Crace, John, "Claude Schopp: The Man Who Gave Dumas 40 Mistresses," *The Guardian*, May 5, 2008.

"Musketeers Carry Dumas to Pantheon," *BBC News*, November 30, 2002.

Cohen, Patricia, "The Haunts of Miss Highsmith," *The New York Times*, December 10, 2009.

Talbot, Margaret, "Forbidden Love," *The New Yorker*, November 30, 2015.

Davenport-Hines, Richard, "Patricia Highsmith's Short Story Noir," *The New York Times*, September 9, 2001.

Guinard, Mavis, "Patricia Highsmith: Alone With Ripley," *The New York Times*, August 17, 1991.

Dawson, Jill, "Carol: The Women Behind Patricia Highsmith's Lesbian Novel," *The Guardian*, May 13, 2015.

Winterson, Jeanette, "Patricia Highsmith, Hiding in Plain Sight," *The New York Times*, December 16, 2009.

Kavanagh, Julie, *The Girl Who Loved Camellias: The Life and Legend of Marie Duplessis*, Vintage Books, 2013.

"La Traviata," *The Opera 101*.

Scott, Bruce, "Verdi's 'La Traviata:' The Original 'Pretty Woman,'" *NPR Music*, February 12, 2010.

Operabase. http://operabase.com/top.cgi?lang=en#opera

"Libiamo ne' lieti calici," *Wikipedia*.

James, Clive, "Belle de Jour and the myth of the happy hooker," *BBC*, November 20, 2009.

Frey, Julia, *Toulouse-Lautrec: A Life*, Orion Publishing, 1995.

Zotti, Alfredo, *Alfredo's Journey: An Artist's Creative Life with Bipolar Disorder*, Modern History Press, 2014.

Trachtman, Paul, "Toulouse-Lautrec," *Smithsonian Magazine*, May 2005.

"Toulouse-Lautrec and Montmartre," *National Gallery of Art*.

Johnson, Ken, "Imbibing a World of Delight and Degradation," *The New York Times*, August 14, 2014.

Smith, Joan, "BOOK REVIEW / Short and not sweet: Toulouse-Lautrec: A Life by Julia Frey, *Independent*, July 9, 1994.

Sooke, Alastair, "How to Cook Like Henri Toulouse-Lautrec," *BBC*, July 29, 2014.

Storm, John, *The Valadon Drama: The Life of Suzanne Valadon*, Dalton, 1958.

Rose, June, *Suzanne Valadon: Mistress of Montmartre*, St. Martin's Press, 1998.

Werner, Alfred, *Amedeo Modigliani*, Thames and Hudson, London, 1967.

Klein, Mason, et al, Modigliani: Beyond the Myth, The Jewish Museum and Yale University Press, 2004.

"Tuberculosis in Europe and North America, 1800-1922," Harvard University Library.

Pogrebin, Robin, "With $170.4 Million Sale at Auction, Modigliani Work Joins Rarefied Nine-Figure Club," The New York Times, November 9, 2015.

"Amedeo Modigliani," Modigliani Foundation. http://www.modigliani-foundation.org/

"Modigliani," Internet Movie Database.

Schjeldahl, Peter, "Long Faces," The New Yorker, March 7, 2011.

"Amedeo Modigliani Portrait Sells for $42M in London Auction," CBS News, February 7, 2013.

Lappin, Linda, "Missing Person in Montparnasse: The Case of Jeanne Hébuterne," The Literary Review, June 22, 2002.

Mata Hari, A&E Television Networks, 2015

Shipman, Pat, Femme Fatale: Love, Lies, and the Unknown Life of Mata Hari, Harper Perennial, 2008.

Wheelwright, Julie, The Fatal Lover: Mata Hari and the Myth of Women in Espionage, Collins and Brown, 1992.

Rennell, Tony, "Mata Hari was only interested in one thing – and it wasn't espionage," The Daily Mail, August 10, 2007.

Lichfield, John, "Was Mata Hari framed?" Independent, October 18, 2001.

"The Woman, The Diva, The Mystery," Dutch National Ballet, 2016.

Stashower, Daniel, Teller of Tales: The Life of Arthur Conan Doyle, Henry Holt & Company, 1999.

Jackson, Kevin, Chronicles of Old London: Exploring England's Historic Capital (Chronicles Series), Museyon, 2012.

Fadiman, Clifton, The Little, Brown Book of Anecdotes, Little, Brown and Company, 2009.

"Fiction imitates real life in a case of true inspiration," Irish Examiner, November 4, 2011.
"Arthur Conan Doyle," stanford.edu, 2006.

Walton, David, "Sherlock Holmes's Maker," The New York Times, May 2, 1999.

Mount, Harry, "How Conan Doyle pioneered skiing…in a tweed suit and 8ft-long wooden skis," Daily Mail, January 29, 2012.

"Influence of Sherlock Holmes," wikia.com.

Geller, Judith B., Titanic: Women and Children First, W. W. Norton & Company, 1998.

Brewster, Hugh, Gilded Lives, Fatal Voyage: The Titanic's First-Class Passengers and Their World, Crown, 2012.

Jasper, Gregg, "The Day I Met a Titanic Survivor," Encyclopedia Titanica, March 24, 2011.

Pellegrino, Charles, "Mrs. Henry B. Harris," charlespellegrino.com, 2006.

Tress, Brian, "Renee Harris," Jewish Women's Archive.

Guinn, Jeff, Go Down Together: The True, Untold Story of Bonnie and Clyde, Simon and Schuster, UK, 2009.

Ramsey, Winston G., On The Trail of Bonnie and Clyde: Then and Now, Battle of Britain Prints, London, 2003.

Jones, W.D. "Riding with Bonnie and Clyde," Playboy, November 1968.

"Public Enemies – Public Enemies in the Great Depression," Awesome Stories, July 1, 2009.

Zeitchik, Steven, "Five Unexpected Ways Roger Ebert Changed Film Journalism," Los Angeles Times, April 5, 2013.

Ebert, Roger, "Bonnie and Clyde," Roger Ebert, September 25, 1967.

Dallas Morning News, May 24, 1934

Dallas Dispatch, May 24, 1934.

Whitaker, Matthew, *Icons of Black America: Breaking Barriers and Crossing Boundaries,* Greenwood, 2011.

Abramovitch, Seth, *"Mo'Nique: I Was Blackballed After Winning My Oscar,"* The Hollywood Reporter, February 19, 2015.

Goff, Kevin John, *"Kevin John Goff in Los Angeles, CA,"* KEVINJOHNGOFF'S BLOG, December 31, 2012.

The Official Academy Awards Database. http://awardsdatabase.oscars.org/

"Hattie McDaniel Biography," *The Biography. com Website.*

"Hattie McDaniel," *fold3.*

"AMC Wins Four Daytime Emmy Award Nominations," *AMC Networks, March 13, 2002.*

Flood, Alison, *"Gone With the Wind Prequel to Tell Mammy's Story,"* The Guardian, April 1, 2014.

Caws, Mary Ann, *Dora Maar - With and Without Picasso: A Biography,* Thames & Hudson Ltd, 2000.

Gilot, Françoise, & Lake, Carlton, *Life with Picasso,* Knopf Doubleday Publishing Group, 1989.

Picasso, Marina, *Picasso: My Grandfather,* Chatto and Windus, 2001.

Chrisafis, Angelique, *"Marina Picasso: selling my grandfather's art is a way of helping me heal,"* The Guardian, May 24, 2015.

Riding, Alan, *"Grandpa Picasso: Terribly Famous, Not Terribly Nice,"* The New York Times, November 24, 2001.

"Maya with her Doll, 1938 by Pablo Picasso," *pablopicasso.org.*

Richardson, John, *"Portraits of a Marriage,"* Vanity Fair, December 1, 2007.

Edwards, Gwynne, *Lorca, Buñuel, Dalí:*

Forbidden Pleasures and Connected Lives, I.B.Tauris & Co Ltd, 2009.

Prose, Francine, *The Lives of the Muses: Nine Women and the Artists They Inspired,* HarperCollins Perennial, 2003.

Espinosa, Patricia, *Salvador Dalí y Gala,* LD Books, 2009.

JP, *"Tales of Salvador Dalí's Demon Bride for Lust of Money and Men,"* The Selvedge Yard, April 17, 2013.

"Gala Biography," *Salvador-dali.org.*

Picardie, Justine, *"Salvador's Siren,"* Telegraph, May 20, 2007.

Meisler, Stanley, *"The Surreal World of Salvador Dalí,"* Smithsonian Magazine, April 2005.

"Gala Dalí Biography," *The Biography.com Website.*

Margolick, David, *Strange Fruit: Billie Holiday, Café Society, and an Early Cry for Civil Rights,* MOJO Books, 2002.

Margolick, David, & Als, Hilton, *Strange Fruit, the Biography of a Song,* Harper Perennial, 2001.

O'Meally, Robert, *Lady Day: The Many Faces of Billie Holiday,* Da Capo Press, 2000.

Atteberry, Phillip D., *"Two Biographies of Billie Holiday,"* The Mississippi Rag, April 1996.

Wilson, John S., *"Barney Josephson, Owner of Café Society Jazz Club, Is Dead at 86,"* The New York Times, September 30, 1988.

Nasaw, David, *"Show-Stopper,"* The New York Times, May 21, 2000.

"The Strange Story Of The Man Behind 'Strange Fruit,'" *npr.org, September 5, 2012.*

"Billie Holiday: A Singer Beyond Our Understanding," *npr.org, April 7, 2015.*

"Desi Arnaz & Lucille Ball," *Entrepreneur.*

"Desilu Productions," *tviv.org, May 8, 2014.*

"Exclusive: Lucie Arnaz Tells Closer, 'I See the World Through My Dad's Eyes,'" *Closer Weekly*, October 25, 2014.

"Exclusive: Inside Lucille Ball and Desi Arnaz's Tumultuous Marriage," *Closer Weekly*, September 9, 2015.

Faraci, Devin, "How Lucille Ball Made STAR TREK Happen," *birthmoviesdeath.com*, September 8, 2013.

Ford, Rebecca, "Lucille Ball Remembered by Hollywood," *The Hollywood Reporter*, August 6, 2011.

Man, Belinda, "DESILU: The family, the success, the productions, and its T.V. impact," *archives.evergreen.edu*.

Smith, Lauren, "At the End of His Life, Desi Arnaz Wrote the Sweetest Thing About Lucille Ball," *HouseBeautiful*, November 30, 2015.

Wayne, Gary, "Seeing Stars: Final Resting Places of the Stars," *Seeing Stars*, 2016.

Guiles, Fred Lawrence, *Loner at the Ball: The Life of Andy Warhol*, Bantam Dell Publishing Group, 1989.

Warhol, Andy, *The Philosophy of Andy Warhol (From A to B and Back Again)*, Harvest, 1977.

Warhol, Andy, & Hackett, Pat, *The Andy Warhol Diaries*, Twelve, 2014.

Bockris, Victor, *The Life and Death of Andy Warhol*, Bantam, 1989.

"The Pop master's highs and lows," *The Economist*, November 26, 2009.

warhola.com http://www.warhol.org/

McGill, Douglas, "Andy Warhol, Pop Artist, Dies," *The New York Times*, February 23, 1987.

Williams, Gilda, "Warhol stumbled across 'The Real America' in the pantry of a woman who never adapted to the American way of life," *Tate*, May 1, 2007.

Kamholz, Roger, "Andy Warhol and His Family," *Sotheby's*, October 25, 2013.

Fur: An Imaginary Portrait of Diane Arbus – Robert Downey Jr., Spike, 2006. http://www.spike.com/video-clips/y7f2xu/ fur-an-imaginary-portrait-of-diane-arbus-robert-downey-jr

Fur: An imaginary portrait of Diane Arbus – Steven Shainberg, Spike, 2006. http://www.spike.com/video-clips/yezou1/ fur-an-imaginary-portrait-of-diane-arbus-steven-shainberg

Austin, Hillary Mac, "Diane Arbus," *Jewish Women's Archive*.

Bryan, Meredith, "Diane Arbus' Times Square Playground," *The Observer*, March 22, 2008.

DeCarlo, Tessa, "A Fresh Look at Diane Arbus," *Smithsonian Magazine*, May 2004.

Frey, Jennifer, "A 'Fur'-Fetched Portrait of Arbus? Precisely! Says the Filmmaker," *The Washington Post*, November 12, 2006.

Leupp, Thomas, "Exclusive Interview with Fur's Steven Shainberg," *Reelz Channel*.

Lubow, Arthur, "The Woman and the Giant (No Fable)," *The New York Times*, April 9, 2014

Macnab, Geoffrey, "She was a Personality Exploding," *The Guardian*, October 6, 2006.

Peek, Kim, Peek, Fran, & Anderson, Stevens, *The Real Rain Man*, Kim Peek, Harkness Publishing Consultants, 1997.

Peek, Francis, & Hanson, Lisa L., *The Life and Message of The Real Rain Man: The Journey of a Mega-Savant*, Dude Publishing/National Professional Resources, Inc., 2007.

Treffert, Darold A., Christensen, Daniel D., "Inside the Mind of a Savant," *Scientific American*, December 1, 2005.

Weber, Bruce, "Kim Peek, Inspiration for 'Rain Man,' Dies at 58," *The New York Times*, December 26, 2009.

"NASA studies mega-savant Peek's brain," *USA Today*, November 8, 2004.

Thangham, Chris V., "Dog Faithfully Awaits Return of His Master for Past 11 Years," Digital Journal, August 18, 2007.

"Hachi: A Dog's Tale," Internet Movie Database, 2009.

Brottman, Mikita, "Richard Gere and Hachiko, the Most Faithful Dog in History," The Telegraph, October 25, 2014.

Itzkoff, Dave, "Film Has Two Big Names and a Dog, but No Big Screens," The New York Times, September 24, 2010.

Betros, Chris, "It's a Dog's Life for Richard Gere," Japan Today, July 10, 2009.

Currey, Mason, Daily Rituals: How Artists Work, Knopf, 2013.

Schenkar, Joan, The Talented Miss Highsmith: The Secret Life and Serious Art of Patricia Highsmith, St. Martin's Press, 2009.

Wilson, Andrew, Beautiful Shadow: A Life of Patricia Highsmith, Bloomsbury, 2003.

Rich, Frank, "Frank Rich on Patricia Highsmith's Carol and the Enduring Invisibility of Lesbian Culture in America," Vulture, November 18, 2015.

Oprah's Next Chapter: Filmmaker Lucas' Near-Death Experience, The Oprah Winfrey Network.

http://www.oprah.com/own-oprahs-next-chapter/Filmmaker-George-Lucas-Near-Death-Experience-Video

The People vs. George Lucas, Alexandre O. Philippe.

George Lucas talks on Star Wars sequels 7, 8 & 9, Killer Movies, September 13, 2004.

Brooker, Will, Using the Force: Creativity, Community, and Star Wars Fans, The Continuum International Publishing Group, New York, 2002.

"Items Taken into Space Reflect Accomplishments on Earth," NASA, October 24, 2007.

Beentjes, Kevin, "A Fish Called Greedo: 10 Species Named After Star Wars," Star Wars, April 1, 2015.

Dunne, Carey, "Weird Facts Behind 6 Famous Star Wars Costumes," CO.DESIGN, February 11, 2015.

"Rebel Jedi Princess Queen Star Wars and the Power of Costume," Smithsonian Institution Traveling Exhibition Service.

"Hollywood Blockbusters, Independent Films and Shorts Selected for 2010 National Film Registry," Library of Congress, December 28, 2010.

Bukszpan, Daniel, "These are the 'Star Wars' Spinoffs, Sequels, and Re-Releases in the Works," FORTUNE, July 13, 2015.

Barnes, Brooks, "For Lucasfilm, the Way of Its Force Lies in Its 'Star Wars' Fans," The New York Times, April 17, 2015.

Curtis, Bryan, "The George Awakens," The New Yorker, January 4, 2016.

Leopold, Todd, "George Lucas: I'm Done with 'Star Wars,'" CNN, November 20, 2015.

Caro, Mark, "The Power of the Dark Side," Chicago Tribune, May 8, 2005.

Emerson, Jim, "How Star Wars Changed the World (As We Knew It)," Roger Ebert, May 23, 2007.

Schou, Solvej, "Mickey Meets 'Star Wars': Walt Disney Co. Completes Acquisition of Lucasfilm," Entertainment Weekly, December 21, 2012.

"Census of Population and Housing — The 2001 Census, Religion and the Jedi," Australian Bureau of Statistics.

"Census 2001 Summary theme figures and rankings - 390,000 Jedi There Are," The National Archives, February 13, 2003.

IMAGE CREDITS

Museyon

Publisher: Akira Chiba
Editor: Janice Battiste
Assistant Editor: Francis Lewis
Cover Design: José A. Contreras

ABOUT MUSEYON

The Mouseion, built in ancient Egypt, was an institute founded to expand our knowledge and dedication to the Muses, the sister goddesses of art, poetry, literature, philosophy and music. It's known as a source for inspiration, and now… as the origin of a curated guide to your obsessions. Accessibly written for the greenhorn as well as the aficionado, the Museyon Guides take you to places you only dreamed existed by curating academic-quality information on your interests and obsessions, alongside visually-oriented travel guides.

"Evoke a strong sense of place"
 —New York Times

"Packs a good bit of history into one handy source"
 —Publishers Weekly

"Graphics that pop, plenty of maps and a breezy tone"
 —Los Angeles Times

"While this is a nonfiction book, it reads like fiction"
 —ForeWord Reviews

"An ingenious approach"
 —Examiner.com

"Lovely, gorgeous and intelligent"
 —Chicago Tribune

"The guidebook-slash-fashion magazine"
 —Nylon

"This little gem is as much fun for the armchair traveler as it is for the tourist"
 —Library Journal

"A pretty damn good job"
 —The Agony Column, Bookotron.com

"Distinctly different"
 —Luxury Travel Magazine

"Small enough to tuck in a bag and not regret the extra weight"
 —She is too fond of books

MUSEYON CHRONICLES SERIES (HISTORY, TRAVEL)

Dramatic true stories spanning the history of each city make these historical guidebooks as enriching for the armchair traveler as for the real adventurer. Walking tours, maps, and archival photographs accompany stories like Thomas Edison's electrification of New York City, the theft of the Mona Lisa in Paris, Lucrezia Borgia at the Vatican, and Oscar Wilde's London.

New York	ISBN 9780982232064
Boston	9780984633401
Las Vegas	9780984633418
Paris	9780984633425
London	9780984633432
Rome	9780984633449
Chicago	9780984633487
San Francisco	9780984633494
Los Angeles	9781940842004

OTHER POPULAR TITLES

Art+Paris Impressionists 9780982232095 • Art+NYC 9780982232088 • The Golden Moments of Paris 9780984633470 • French Riviera and Its Artists 9781940842059 • Cool Japan 9780984633456

ABOUT THE AUTHOR

Maria Bukhonina is a world traveler, writer and television producer. She is a co-creator and executive producer of the television program *Booze Traveler*, which explores cultures around the world through their native libations. In this book, Maria continues to explore her favorite subjects of creativity, destiny and the power of the human spirit.